Georges Seurat

(1859-1891)

PARKSTONE®
INTERNATIONAL

Page 4:
Georges-Pierre Seurat
Photograph

Author:
Lucie Cousturier

Layout:
Baseline Co. Ltd
61A-63A Vo Van Tan Street
4ᵗʰ Floor
District 3, Ho Chi Minh City
Vietnam

© 2013 Confidential Concepts, worldwide, USA
© 2013 Parkstone Press International, New York, USA
Image-Bar www.image-bar.com

ISBN 978-1-78160-237-9

Printed in Poland

Art is harmony. Harmony is the analogy of contrasts, the analogy of similarities, of tone, of shade, of line, considered by the dominant, and under the influence of happy, calm, or sad lighting combinations.

— Georges Seurat

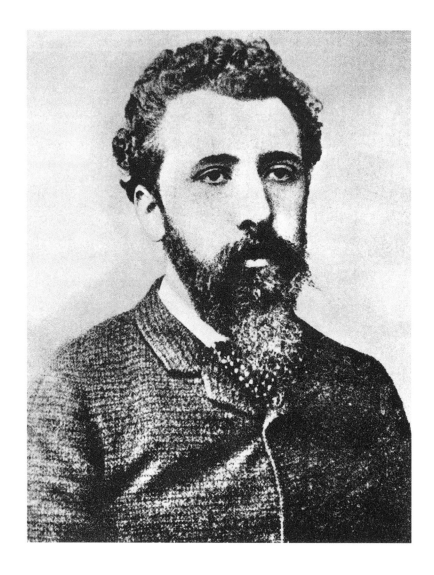

Biography

1859: Georges-Pierre Seurat was born in Paris into a bourgeois family. His aunt was the wife of art dealer and amateur painter, Paul Homonté. This uncle was of particular influence to the young Georges as he introduced him to the practice of painting. Seurat was drawing from the age of nine.

1876: Seurat enrolled in the École Nationale des Beaux-Arts in Paris as an external auditor.

1878: Enrolled definitively in the École Nationale des Beaux-Arts in Paris in the department of painting. The painter Henri Lehmann (1814-1882), a former student of Ingres, was amongst his professors. It was during this period that Seurat read a scientific treaty on colours for the first time. He began with *De la loi du contraste simultané de couleurs* (1839) by the chemist Eugène Chevreul.

1879: Seurat opened a workshop with his friends Edmond Amand-Jean (who became a Symbolist painter) and Ernest Laurent who followed him into Neo-Impressionism. Together they visited the fourth Impressionist exhibition, and Seurat then decided to leave the Beaux-Arts. Georges left to complete his military service in Brest, returning one year later with numerous drawings of seascapes.

Seurat

1882: He began to devote himself to the study of black and white and to the contrasts between colours, which would become the foundation for his artistic technique.

1884: Seurat exhibited his first big composition, *Bathers at Asnières*, at a salon for independent artists (Salon des Indépendants). There, he encountered painters who formed the Neo-Impressionist group. These included Charles Angrand, Maximilien Luce, Henri Cross, and Paul Signac.

1884-1890: During the summer, Seurat made several trips to Normandy, to the seaside, notably at Grandcamp-Maisy, Honfleur, and Port-en-Bessin. These seascapes were of great inspiration to him, and he brought back many paintings and drawings.

1886: He finished what is without doubt the most famous of his canvasses, *A Sunday on La Grande Jatte*, and exhibited it during the second Salon des Indépendants.

1890: His son, Pierre Georges, from his liaison with the model Medeleine Knobloch, was born. His family and friends consequently discovered this relationship, which had been previously kept hidden.

March 1891: Georges Seurat died suddenly, most probably from diphtheria. His son died from the same illness a month later.

The Paintings

If the fame which the names of Cézanne and Renoir have retained has bypassed Seurat, it is because the latter's works, which were immediately snapped up and fixed in private collections, have almost no contact with the public.

Portrait of a Young Woman (The Artist's Cousin?)

c. 1877-1879
Oil on canvas, 30.4 x 25 cm
The Dumbarton Oaks Research Library and Collections
Washington, D.C

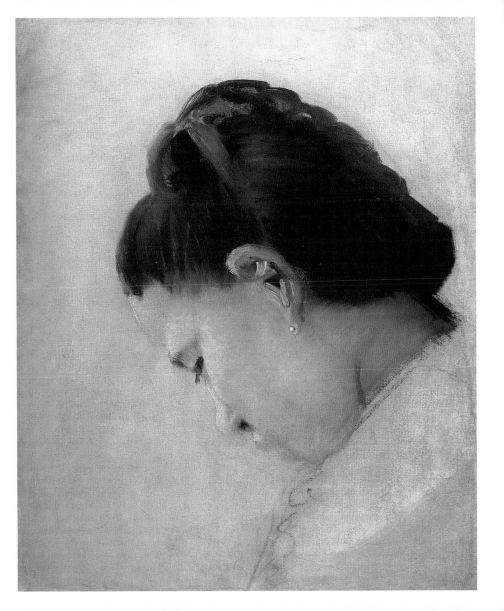

It was through successive works that the artistic innovators appeased the clamouring masses. Their total production of works is like a conversation which, by subtle styles and nuances, sways the viewers. Had Seurat continued to live beyond his thirty one years, nothing could today escape the domination of his work, which the vigour of his

Woman on a Bench (Repairing her Coat)

1880-1881
Pencil, 16.5 x 10.4 cm
Robert and Lisa Sainsbury Collection
Sainsbury Centre for Visual Arts, Norwich

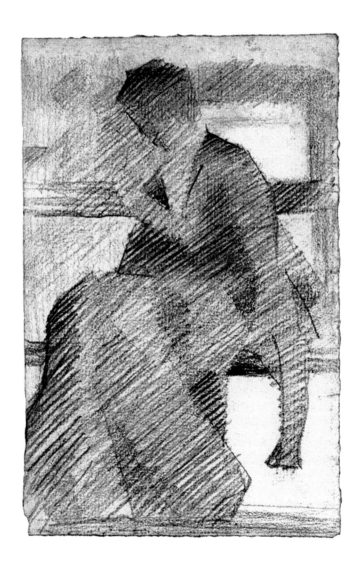

character and his creative powers promised to equal that of Eugène Delacroix. Seurat is a great painter little known to the larger public. Even whilst he was alive his personality presented the anomaly of a youthful vision, yet worthy of the ancients, and a unique boldness in realising his vision alone,

The Hood
———————

c. 1881
Conté crayon on Michallet paper, 30.5 x 24 cm
Von der Heydt-Museum, Wuppertal

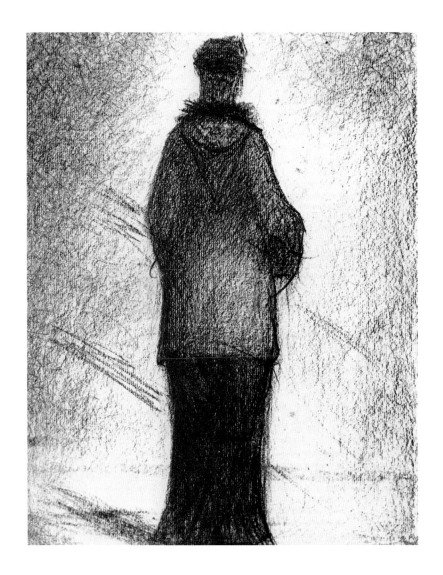

without the help of the gods. It could be understood that the emergence of such an innovator, who happened to peak in this period, and whose disruptive formulas so quickly succeeded the force of the Impressionists, had angered the public, who perceived it as a challenge of their weakness. But the laughter and mockery of the crowds, and

Lying Man
———
c. 1881
Conté crayon on Michallet paper, 23.2 x 32 cm
Private collection, Switzerland

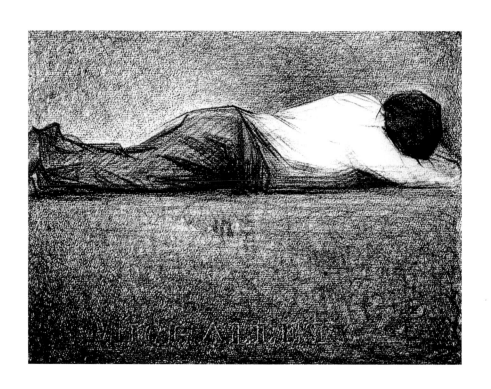

15

even of those close to him, which was unleashed in front of his exhibitions in Paris, New York, Brussels, and Amsterdam, didn't trouble the painter, as he was little concerned with success and luxury. Effectively, he chose to build his artistic practice according to precise scientific laws. He wanted to find and prove the existence of a link

Kneeling Woman

c. 1881
Conté crayon on Michallet paper, 31.8 x 24.1 cm
Private collection

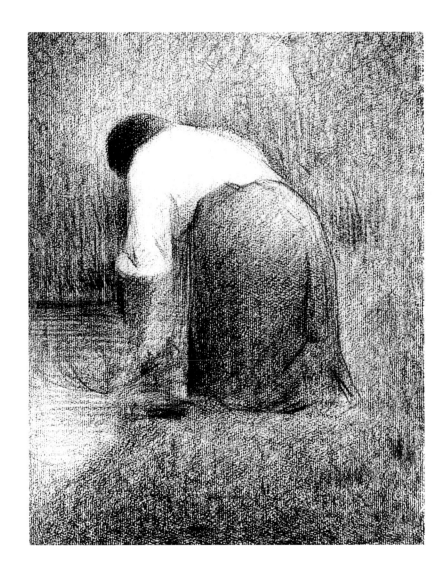

between art and science. Based on optics, on the interplay between points of colour, his theory is now called Pointillism.

Georges Seurat was born to a wealthy family in Paris, December 1859. After school, where he stayed until the age of sixteen, he worked for four years in the École Nationale Supérieure des

The Forest at Pontaubert

1881
Oil on canvas, 79.1 x 62.5 cm
The Metropolitan Museum of Art, New York

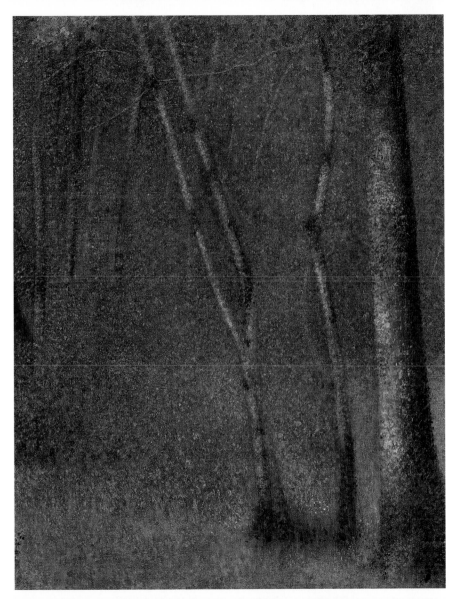

19

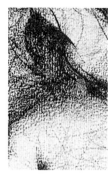

Beaux-Arts in Paris before embarking on more personal pathways, working independently from the artistic and museum institutions already in place. Seurat's physical appearance was similar to the ideas that he created for his figures in his paintings: slender, rigid, and calm. He had a strict attitude, from which his high and full forms grew and

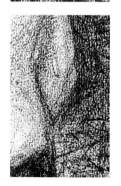

Artist

———

c. 1881-1882
Conté crayon and chalk on Michallet paper, 47 x 31 cm
Private collection, London

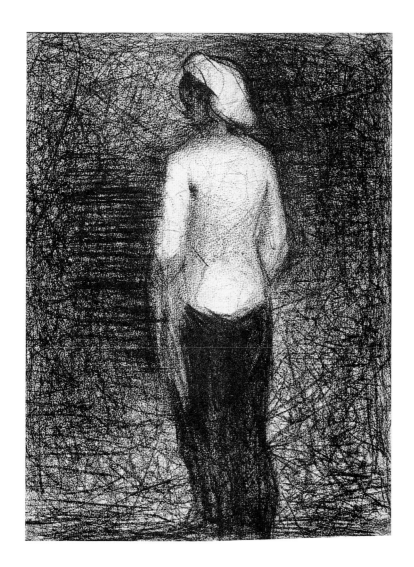

developed, that balanced the burning outbursts of his soul. No agitated movements could disturb his proud bearing, nor would any troubled expression cross his face, his features immobile and even. But during a brief art symposium, he revealed a burning gaze and an emotional voice, strangled by his impatience to affirm his cherished convictions.

The Mower

1881-1882
Oil on wood, 16.5 x 25.1 cm
Robert Lehman Collection
The Metropolitan Museum of Art, New York

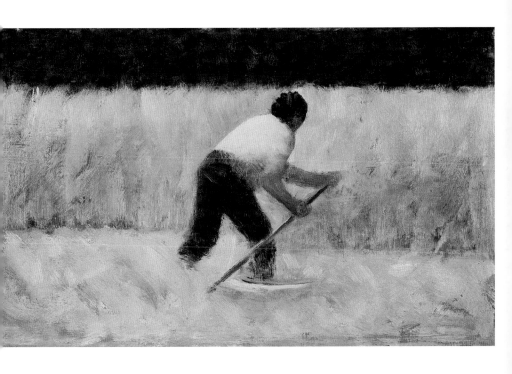

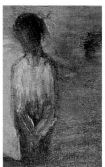

Seurat, absorbing the tenderness from light and beings, was himself a gentle soul. This could be indicated by his soft velvet gaze and dark eyebrows, but he revealed himself to be umbrageous when anyone touched upon his secretly maintained inner being. Ordinarily unconcerned with advancing to the forefront of discussions and lectures, he went to

Landscape with "The Poor Fisherman"
by Puvis de Chavannes

c. 1881
Oil on wood parquet, 17.5 x 26.5 cm
Musée d'Orsay, Paris

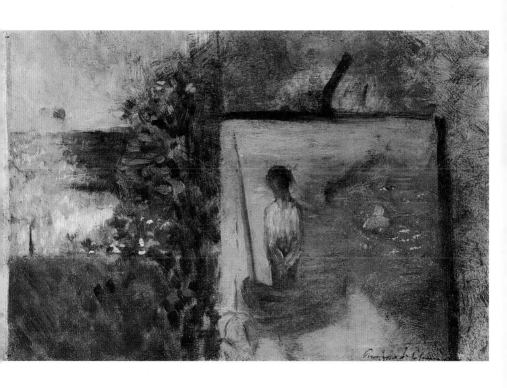

them with the hope of nourishing the painter inside of himself. He emerged from his inner life with the ardour of a hunting wolf, yet it was impossible to follow him back into retreat.

He showed himself to be as outgoing with his mother, with whom he took his daily meals, as with his intimate friends. Paul Signac, Maximilien Luce,

Man with a Parapet. The Invalid

c. 1881
Oil on wood, 16.8 x 12.7 cm
Private collection

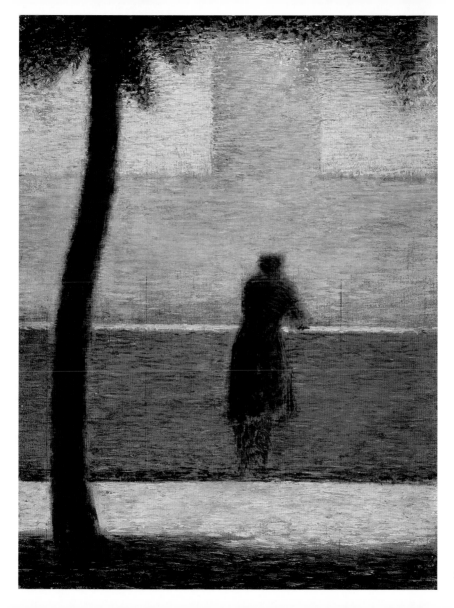

Charles Andrand, and Félix Fénéon ignored Seurat's long-term domestic installation almost until his death. His partner bore him a son, fated to pass away along with Seurat, a victim of the same sickness. Seurat's death, when he was aged but thirty-one, occurred following a severe case of diphtheria. This illness claimed both father and

Peasant with Hoe (Paysan à la houe)

1882
Oil on canvas, 46.3 x 56.1 cm
Solomon R. Guggenheim Museum, New York

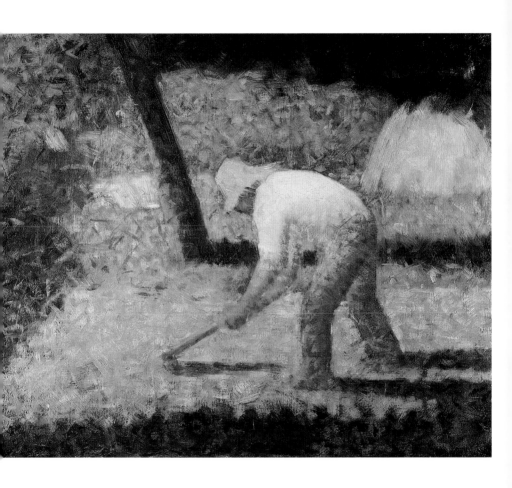

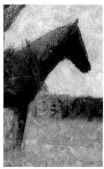

son as victims within the space of a few weeks. Witnesses to the artist's manic work were of the opinion that his death was the result of the weakening of his body, worked beyond the capacity of human resistance.

Seurat painted day and night. During the last years of his short life, he remained fixed for

Horse in a Field

c. 1882
Oil on canvas, 33 x 41 cm
Solomon R. Guggenheim Museum, New York

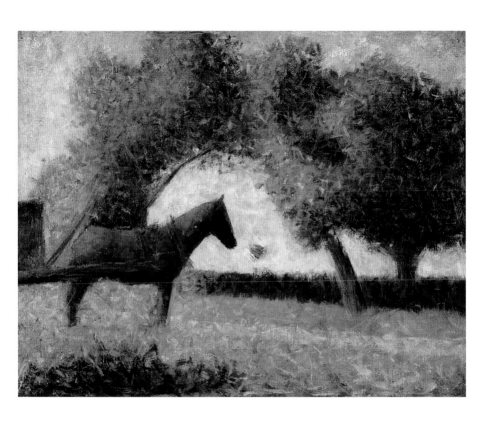

long hours at his canvasses, hastening in the application of patches of rainbow colours, representing local colours, lights, and reactions. Their proportions, observed in direct study, were so definitely fixed in his spirit, that he could distribute them even on the largest surface without a single bad element springing forth and

Nurse

———

c. 1882
Conté crayon on Michallet paper, 32 x 25 cm
Museum Berggruen, Staatliche Museen zu Berlin, Berlin

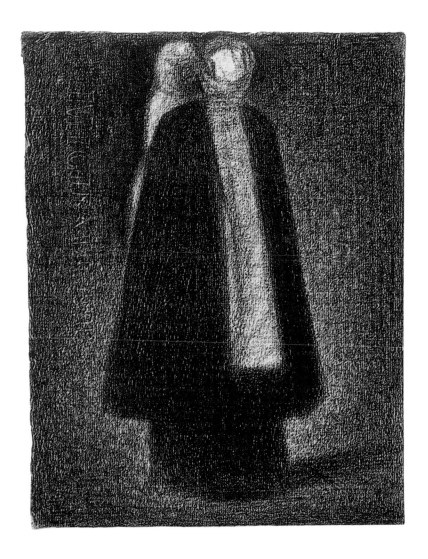

33

demanding attention away from the absorbing power of the overall picture. Thus, he was able to assure the mathematical harmony of his compositions, under any condition of distance or degree of light. Have we not seen that he worked long into the night despite the betrayals of artificial light which was rendered necessary to him?

Woman Knitting

1882
Conté crayon on Michallet paper with
metallic silver paint and black chalk, 32.2 x 24.5 cm
Harvard Art Museums, Cambridge

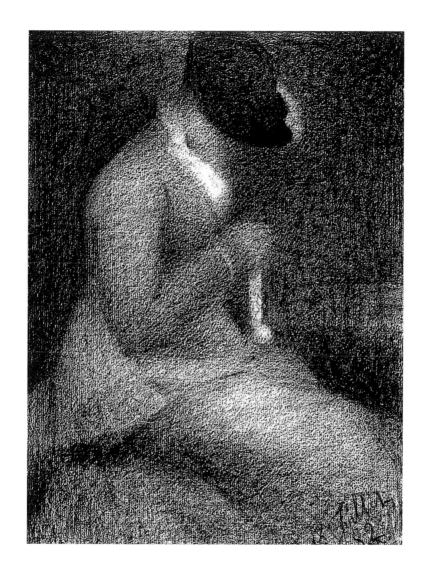

This permanent tension arising from a spirit concerned with adhering to precise visions, or with favouring new concepts, gave Seurat a seriousness from which he rarely departed. He could always be found at his easel in his modest studio in Montmartre. He would quickly rush from this upon the first query of a visitor, to the

The Stone Breaker

1882
Oil on wood panel, 15.6 x 24.8 cm
The Phillips Collection, Washington, D.C

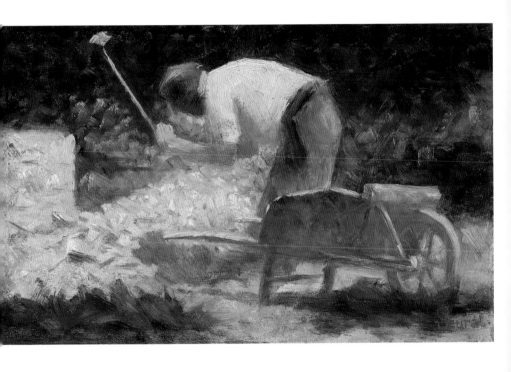

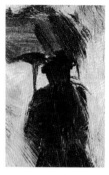

floorboards to demonstrate the benefits of a theory based on the expressive power of certain angles and certain volumes in large figures with chalk. Even when visiting his friends, in conversation, which he never joined for long, he let little distract him from these obsessions. He would quickly be arrested by any and every painting,

On the Street

c. 1882-1883
Oil on panel, 16.5 x 24.7 cm
Private collection, Switzerland

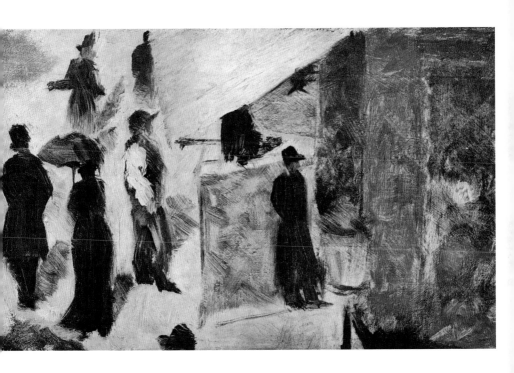

39

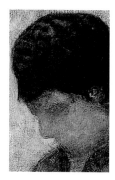

and would be absorbed in long meditation in front of the canvasses of his friend and disciple Paul Signac. From cafés, bars, to even music-halls, and night-time meetings which he accidentally followed his comrades to, he was never prone to recklessness or childish fantasies as they were. On the contrary, always reasonable,

Boy Sitting in a Meadow

c. 1882-1883
Oil on canvas, 63.5 x 79.6 cm
Kelvingrove Art Gallery and Museum, Glasgow

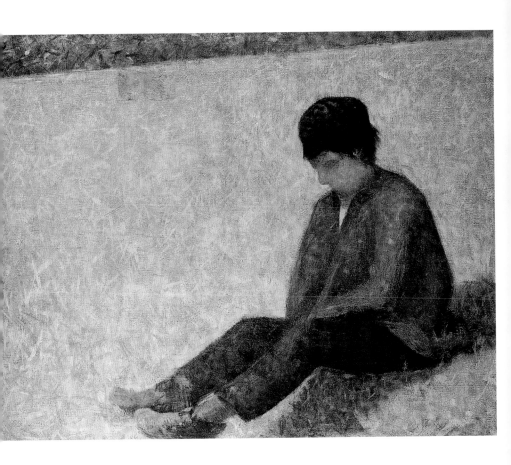

he would stop them as soon as they found themselves on the street at midnight, before the phantasmagoria of chiaroscuro. The painter observed; delighted and fascinated by the graceful distortion of the slender flower of an ordinary street lamp, devoured at its pinnacle by the radiating gas flame, and at its base, the paleness of the moon gnawing away at its black stem.

Madame Seurat, the Artist's Mother

c. 1882-1883
Conté crayon on Michallet paper, 30.5 x 23.3 cm
J. Paul Getty Museum, Los Angeles

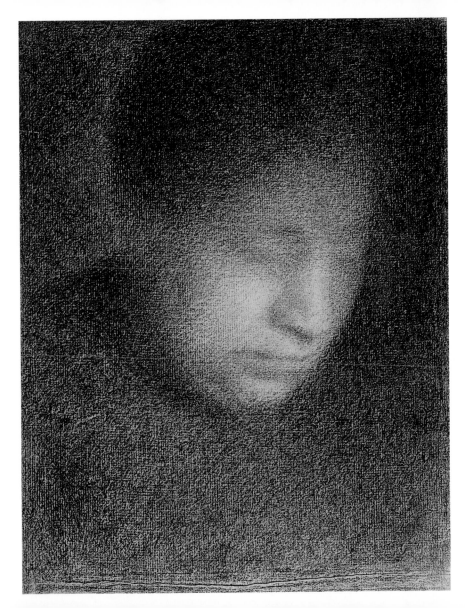

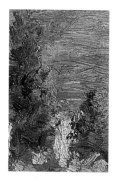

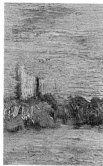

This painter's development and artistic maturity, essential to art history, is comprised of three steps:

That of the study of chiaroscuro, of the opposition between black and white, colours which in his eyes are complete in their own right, in his conté drawings; 'the most beautiful of the artist's drawings there are' wrote Paul Signac.

Riverbanks
———

c. 1882-1883
Oil on panel, 16 x 25 cm
Kelvingrove Art Gallery and Museum, Glasgow

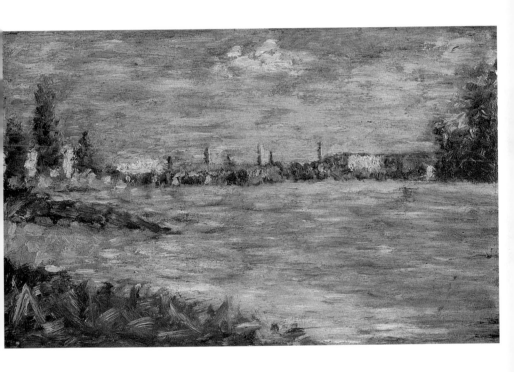

That of the direct work from nature, including oil paintings executed with broad brushstrokes, on small wood panels. Fénéon owned a poignant series of numerous documents and sketches for his larger paintings of great landscapes.

That of synthetic landscapes with human figures, which start with *Bathers at Asnières*

Suburb

1882-1883
Oil on canvas, 32.2 x 41 cm
Musée d'Art moderne, Troyes

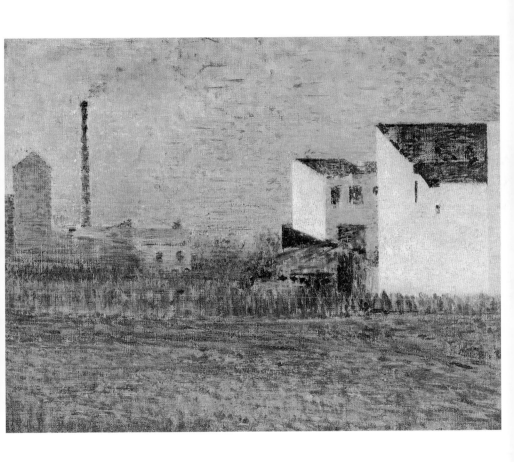

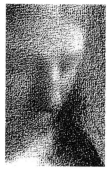

(1884), following with *A Sunday on La Grande Jatte* (1886), *Circus Sideshow* (1889), *Le Chahut* (1889-1890), and finally *The Circus* (1891).

We have an understanding of which beliefs were brought to these last works, through the ideas shared by Paul Signac (Signac had also drafted a

Embroidery; The Artist's Mother

1882-1883
Conté crayon on Michallet paper, 31.2 x 24.1 cm
Lillie P. Bliss Collection
The Metropolitan Museum of Art, New York

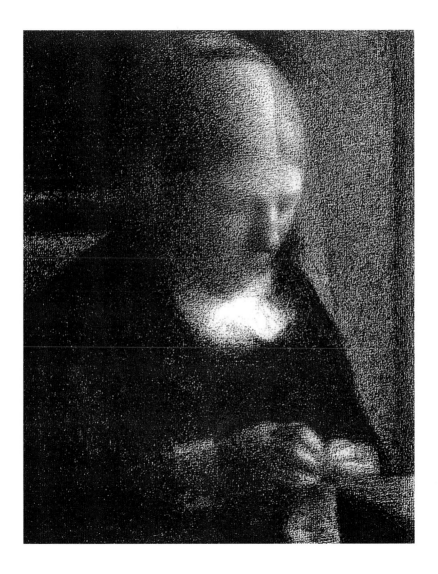

49

work entitled *De Delacroix au Néo-impressionnisme* which explained his aesthetic thoughts). Whilst Signac painted first in the style of the Impressionists and only separated himself from this style due to the need to order the harmonised sets of colour which he observed in their canvasses, Seurat at this time

Farm Women at Work (Paysannes au travail)

1882-1883
Oil on canvas, 38.5 x 46.2 cm
Solomon R. Guggenheim Museum, New York

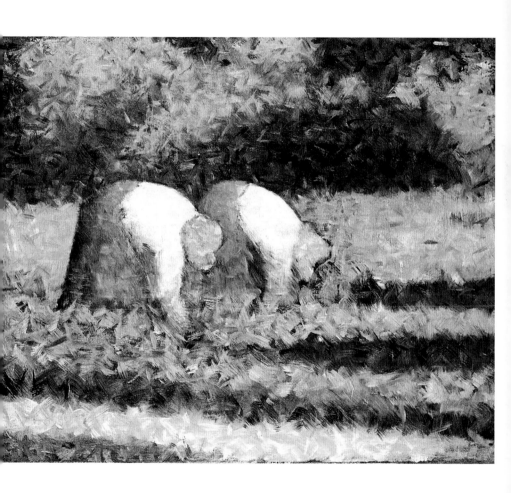

ignored the Impressionists. Rather, he was persuaded of the necessity to reject formal education, and to liberate the elements of a new theory in the example of Eugène Delacroix and scientific writings on colour. His analysis of works by this painter, facilitated by physicists (for example, Rood, Helmholtz, Chevreul, and

White Houses, Ville d'Avray

1882-1883
Oil on canvas, 33 x 46 cm
Walker Art Gallery, Liverpool

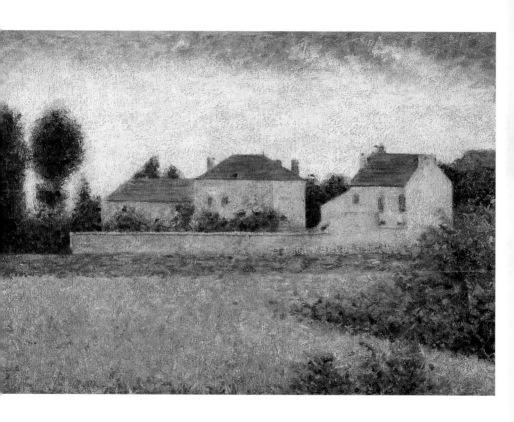

Humbert de Superville), allowed him to formulate an ensemble of eternal laws governing colour, values, and lines. For him, light was the result of a combination of several colours. In this way the points of colour placed next to each other can generate light with a high degree of accuracy if the right colours are chosen.

The Stone Breakers, Le Raincy

c. 1882
Oil on canvas, 37.5 x 45.4 cm
Norton Simon Art Foundation, Pasadena

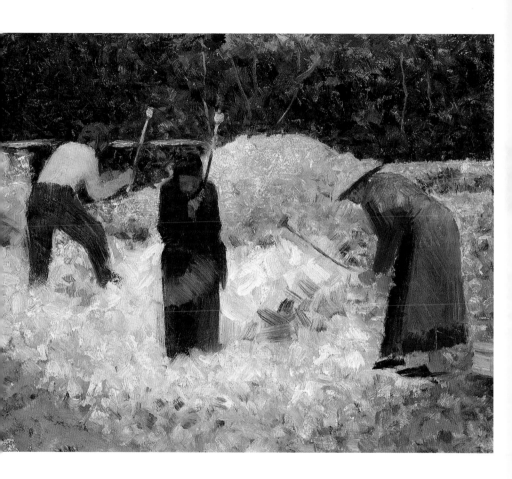

With the aim of best observing them, he concluded the usefulness of the technique of dividing colours which can be clearly expressed through prism shades, contrasts, and gradients. Through these measures, colour can reach its maximum saturation, by which powerful values are reached. This is what is called "Chromoluminarism"

The Gardener
―――――――――――
1882-1883
Oil on wood, 15.9 x 24.8 cm
The Metropolitan Museum of Art, New York

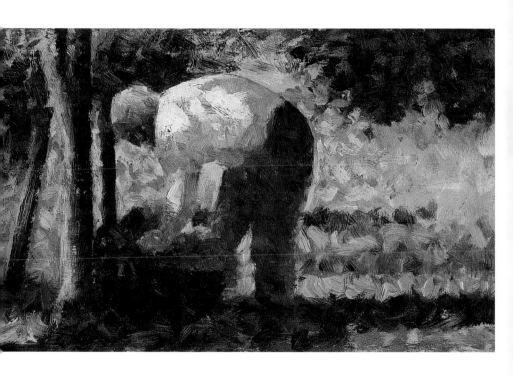

(also known as Divisionism). It is built around the idea of complimentary colours (red-green, orange-blue, yellow-purple), distinction between shade and tone (colour and value), the idea of optical mixing not only on the palette but also in the viewer's retina, and exalting colour by the juxtaposition of different tones of the same shade.

Fort Hall

———

c. 1882
Conté pencil, 31.5 x 25 cm
Jan and Marie-Anne Krugier Collection, Geneva

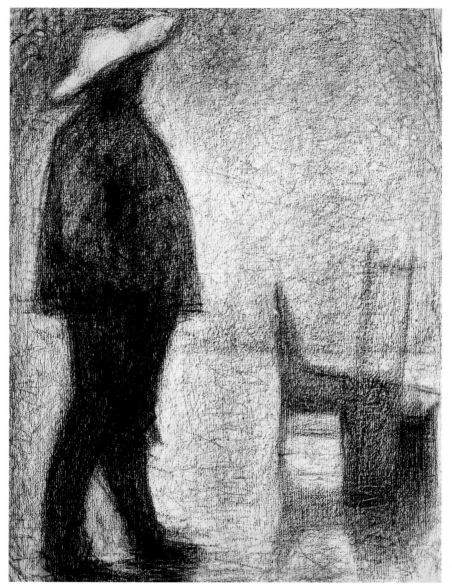

59

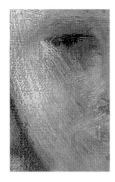

Under his dictation, Jules Christophe summarised Seurat's theory in 1889:

Art is harmony; harmony is the analogy of contrasts, the analogy of similarities (gradients), of tone, of shade, and of line. Tone, that is to say, the light and the dark; shade, that is to say,

The Little Peasant in Blue

c. 1882
Oil on canvas, 46 x 38 cm
Musée d'Orsay, Paris

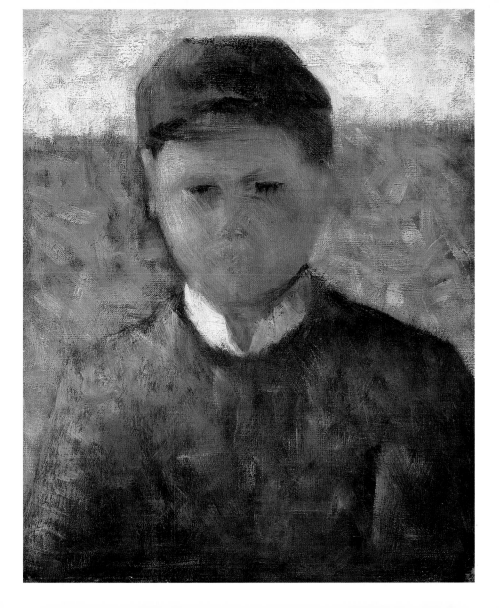

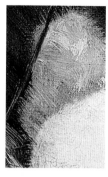

red and its complimentary green, orange and blue, and yellow and violet; line, that is to say, the direction on the horizontal. These diverse harmonies are combined in happy, calm, and sad groupings. Gaiety of tone is the dominant luminosity; in shade, it is the dominant warmth,

The Day Labourer

c. 1882
Oil on canvas, 33 x 41 cm
Private collection

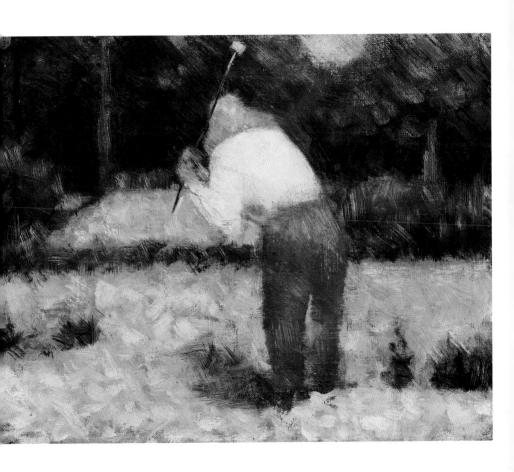

63

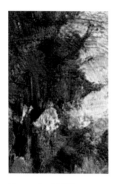

and in line, the ascending directions (over the horizontal). The calm tone is the equality between light and dark, of warmth and cold for the shade, and the horizontal for line. The sadness of tone is the dominant dark, for shade, the dominant cold, and for line, lower directions.

Barbizon Landscape

c. 1882
Oil on wood, 16 x 25 cm
Private collection, New York

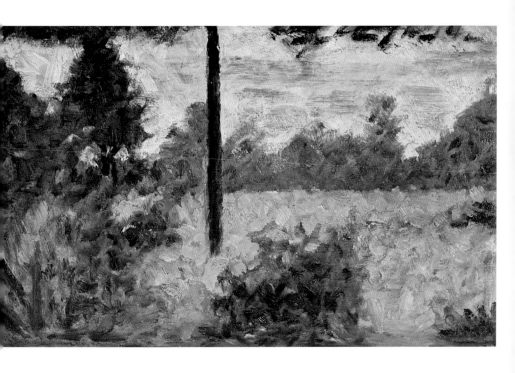

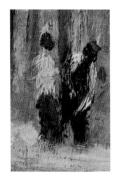

Georges Seurat was first assured of the benefits of his theory whilst experimenting with black and white values in his drawings, the expressive power of the contrast of tone. By passionately, but logically, changing his conté pencil strokes on a sheet of Michallet paper, through contrasts he

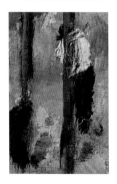

Peasants Driving Piles

c. 1882
Oil on wood, 14.9 x 25 cm
Private collection, New York

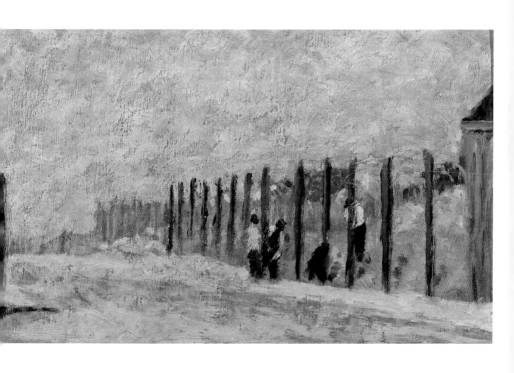

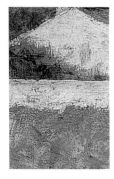

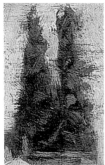

extolled radiant or matte whites (thereby joyful or abrupt), and severe and poignant blacks.

The new beauty and definition of these drawings is what the artist entrusted to us, without any paltry conditions, through the expression of his thoughts on the eloquence found in the contrast of black and white. He did not overburden the masses who, with these vain picturesque details,

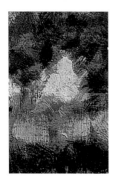

House among Trees

c. 1883
Oil on panel, 15.6 x 25.1 cm
Kelvingrove Art Gallery and Museum, Glasgow

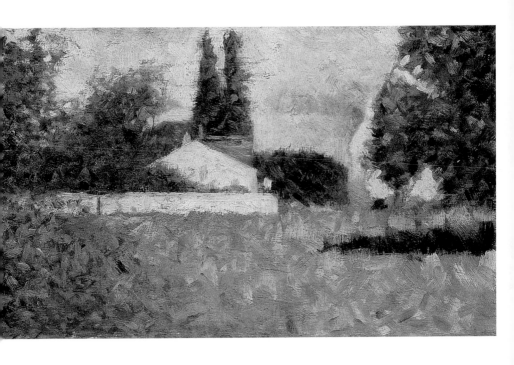

would have become speechless in the discussion of the off-white and less intense black. He did not stop, for example, to evoke the splendour of a naked back in order to depict muscles and fleeing contours. No, on the contrary, he was content to extol the luminous radiance of the flesh, either by rousing the whites with the blacks jumping from the frame, or just as

Study for Une Baignade

c. 1883
Oil on panel, 15.9 x 25 cm
National Galleries of Scotland, Edinburgh

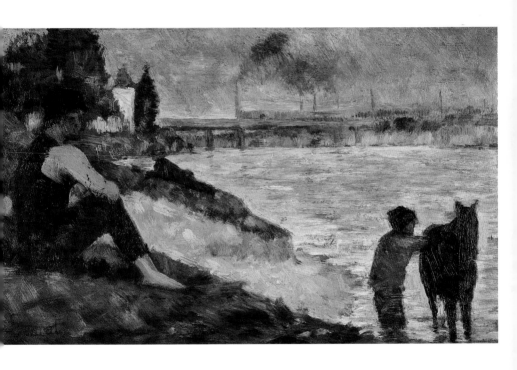

easily by soothing them with soft curves until they became a powerful silhouette of shadow.

When Seurat extended the application of effective contrasts to Chromaticism, it was a decision equally exempt of weakness. He rejected without emotion what was taught at school; the method of mixing colour in order to seduce the eye, and the prestige of selling works created.

Man Painting a Boat

c. 1883
Oil on panel, 15.9 x 25 cm
The Courtauld Gallery, London

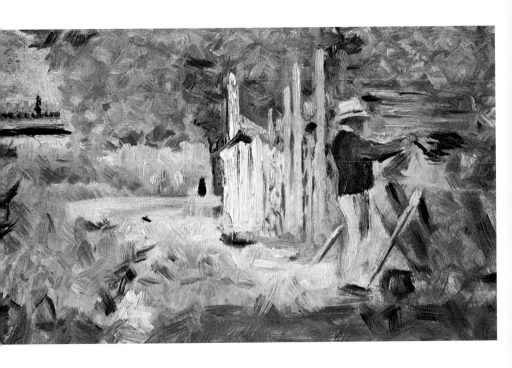

What he wanted to express was urgent and could not wait.

Equipped with his impersonal method, Pointillism, which was used to meet the requirements of a bold bias, he conquered his paintings with sureness, showing neither deviation nor fear. He sat before nature but it was with the primary purpose to above all capture the trees,

Family Scene, Evening

c. 1883
Conté crayon on Michallet paper, 24.1 x 31.4 cm
Allen Memorial Art Museum, Oberlin (Ohio)

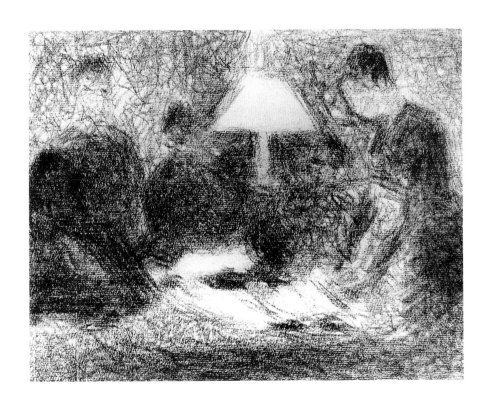

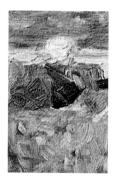

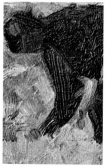

terrains, people, clouds, etc. in their basic proportions and values. As his pursuit of light was of special importance to him, his shades were initially of little variation, but delicately expressed. When he hastened in his work, it was the warm tone of the wooden panel which permeated through the brushstrokes, so that the sunlit foliage,

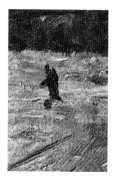

Farmer at Work

c. 1883
Oil on wood, 17 x 25 cm
Private collection, Paris

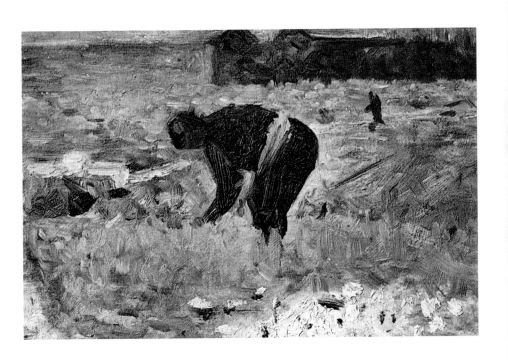

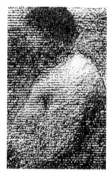

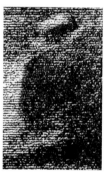

for example, gathered the necessary orange additions to create a harmonious flow with a blue sky.

In the same manner, little by little he increased the hues with strict expressive usages. Take, for example, the figure of a crouching woman, which featured within the collections of Félix Fénéon.

Laundry on the Line

c. 1883
Conté crayon on Michallet paper, 22 x 30 cm
Musée d'Art moderne, Troyes

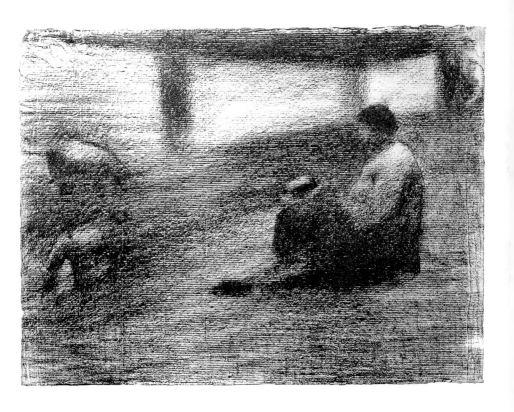

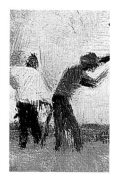

The quality of mauve in this moving block of shadow, isolated in reddish light, favours the serious expression of the figure, whose accentuated silhouette imposes on the surrounding prairie.

Later, after a stay in Basse-Normandie, he painted *View of Fort-Samson* (1885), *Evening,*

Les Terrassiers

c. 1883
Oil on wood, 14.6 x 24 cm
Paul Mellon Collection, Upperville (Virginia)

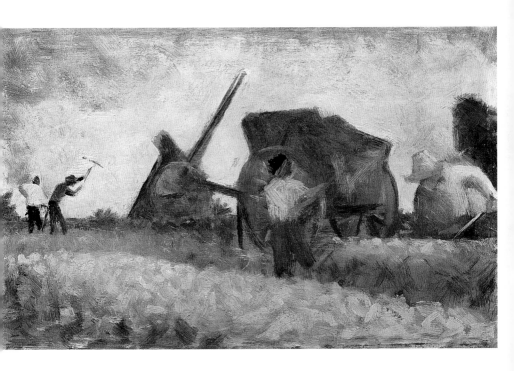

Honfleur, and *Le Crotoy, Downstream*. He took hold of the secret angles which secure the terrain and architecture; he invented the sands, the sand! Let alone his rhythm, his luminosity, and the subtlety of his hues. By fully using his capacity as a painter, he was able to assess the

The Watering Can

c. 1883
Oil on wood, 24.8 x 15.2 cm
Paul Mellon Collection, Upperville (Virginia)

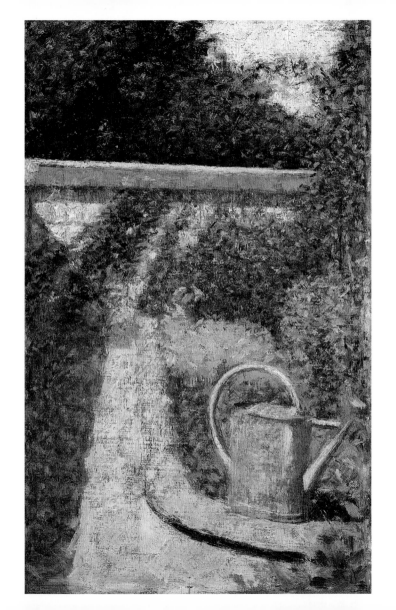

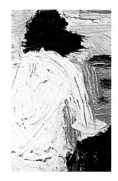

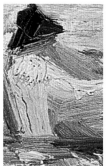

densities of all the skies and all the waters with the nuances of an exquisite tenuity. But in the countries of his conquests, as he called them, he gave emphasis to them above all, by infinite close and imperial degrees, to the point of the adoration of magical light, shining in a beautiful unity of solemn

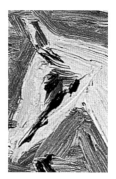

Bathers and a White Horse in the River

1883
Oil on wood, 15.3 x 24.5 cm
Paul Mellon Collection, Upperville (Virginia)

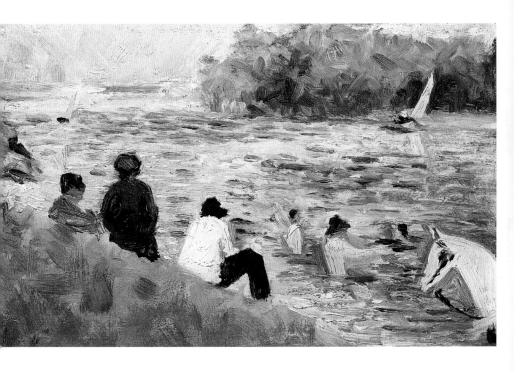

or fair colours. Certainly, this unity would matter little if the methods were not of the heart. It is easy to crudely ensure the triumph of a white or a red on a canvas, and whilst in a painting by Seurat nothing is too much, it is only in this measure of the heart where he captures our delight.

Peasant Woman Seated in the Grass
(Paysanne assise dans l'herbe)

1883
Oil on canvas, 38.1 x 46.2 cm
Solomon R. Guggenheim Museum, New York

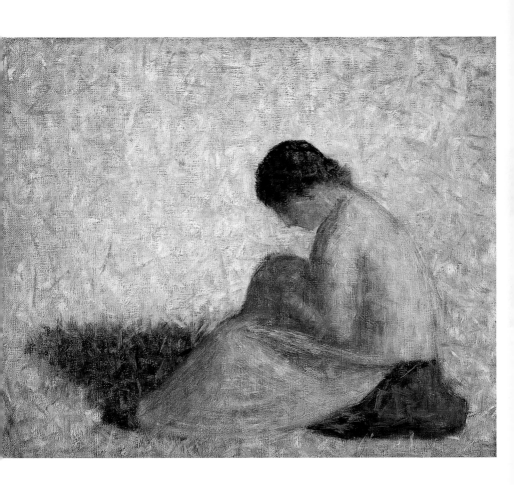

All of the painter's works benefitted from this exquisite sensitivity, filled with elements taken from direct observation, which attested to his rigorous decision-making. But of these latter, there is no chatter, not even a whisper, on any part of their surface to disturb the art's joyful song.

Seated Boy with Straw Hat

1883
Conté crayon on Michallet paper, 25.4 x 30.5 cm
Yale University Art Gallery, New Haven

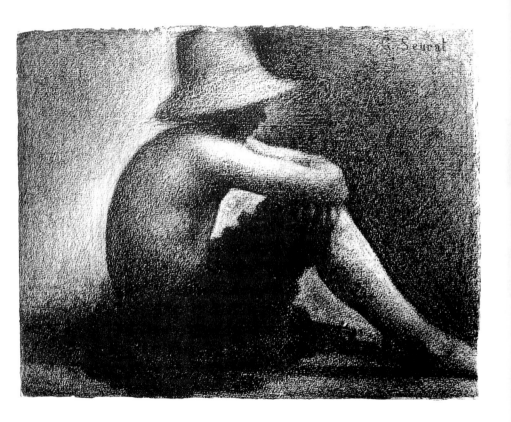

89

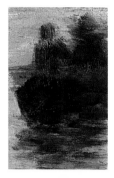

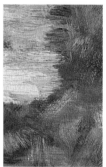

The theory of balance, applied to all of these great compositions, certainly guarantees their steadfast and worthy position.

Bathers at Asnières was the first of seven big canvasses which he painted during his short lifetime, and exposed to the Salon des Indépendants in 1884 after being refused by the

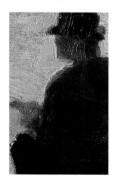

Fishermen on the Banks of the Seine

1883
Oil on canvas, 15.7 x 24.4 cm
Musée d'Art moderne, Troyes

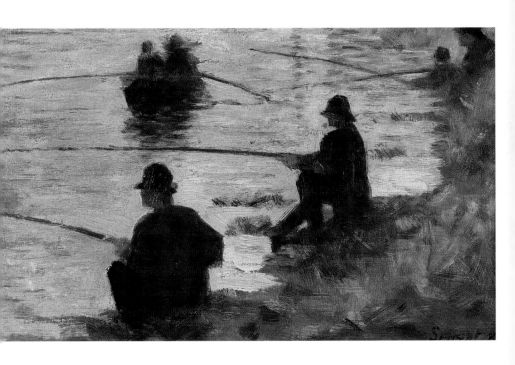

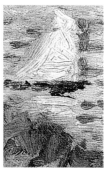

official Salon. In this work, the painter's vision was revealed in fragments of rare quality indeed, through the somewhat surreal characters that submerge themselves in the nude, or lounge on the banks of the Seine. Nevertheless, all of Seurat's magnitude and watchful eye is present in the

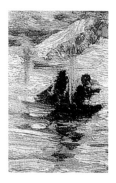

Horses in the Water

1883
Oil on panel, 15.2 x 24.8 cm
Private collection, on long-term loan to
The Courtauld Gallery, London

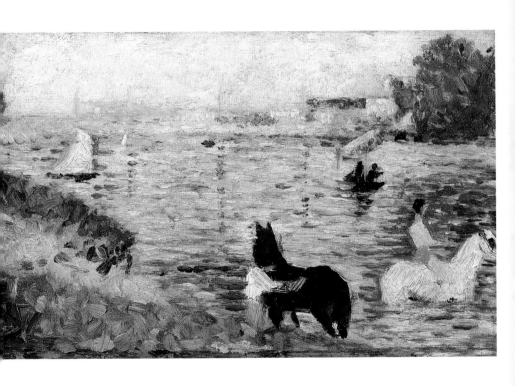

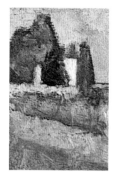

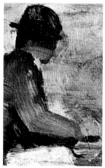

orchestration of resounding new shades of colour with the power to propagate the volume of a glorious light to the point of its diffusion, then calmed by the blue of a delicate background. Whilst, in this painting, the silhouettes are immersed in different activities, it contrasts with

Study for Bathers at Asnières

c. 1883-1884
Oil on wood panel, 15.7 x 24.9 cm
Cleveland Museum of Art, Cleveland

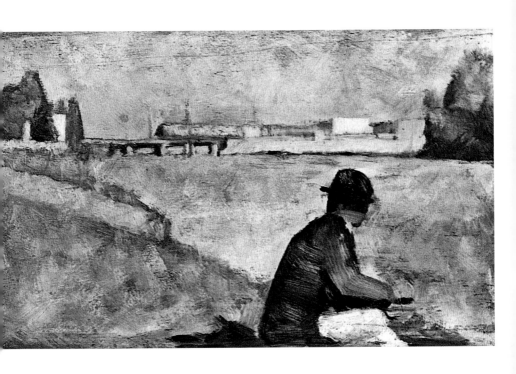

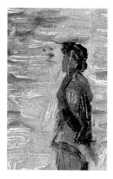

the significant energy of the arabesque of the shadows which appear in *La Grande Jatte*, in the midst of a sun-filled space.

In order to make the viewer's gaze hurry to the direction of the contours of these great figures, the painter did not illuminate their expressions,

Study for La Grande Jatte

1883-1884
Oil on wood, 16.5 x 24.4 cm
Mr and Mrs Walter Salomon Collection, London

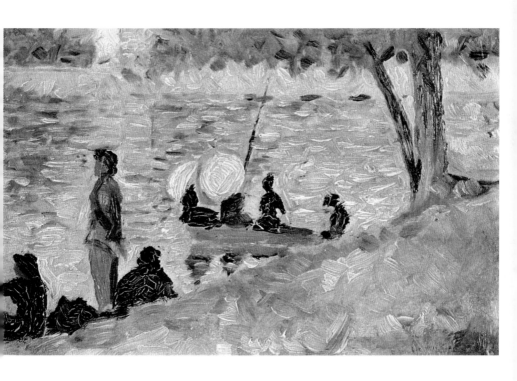

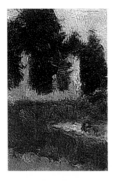

lest their faces distract. Their youth and liveliness are only revealed by the curve and quality of shade. Take note, for example, of these miracles of freshness and fragrant life: the face of the woman with the black parasol, and that of the child dressed in white have only suggested, not precise,

Clothes on the Grass
―――――――――――

1883
Oil on wood, 16.2 x 24.8 cm
Tate Collection, London

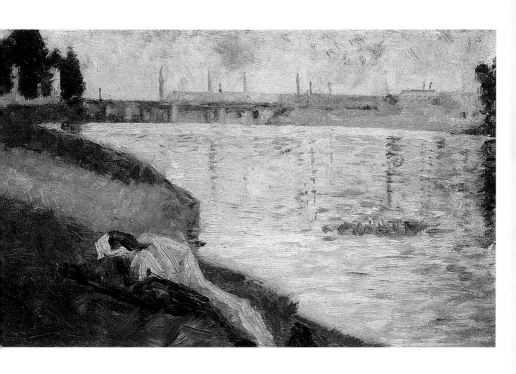

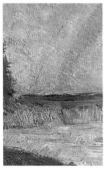

features. The slightly grotesque fashions which prevailed in 1886 inspired Seurat to create these lively and elegant architectures, so simply arranged, which quietly push back their clear backgrounds by the power and variety of their tones.

Félix Fénéon, with a concise description of this subject, precisely suggested which balances conjure the calm which pervades this composition:

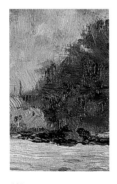

The Rainbow, study for Bathers at Asnières

1883
Oil on wood, 15.5 x 24.5 cm
The National Gallery, London

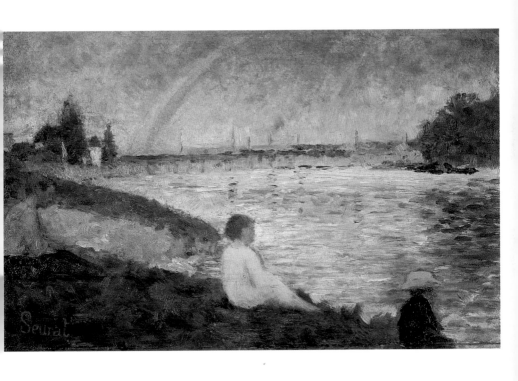

With a scorching sky, at 4 o'clock, the island, the floating barges at the side, the sailing boats of a Sunday, filled with a casual crowd enjoying the great outdoors, amongst the trees, and these forty-something characters are created within a hieratic and concise drawing,

Winter in the Suburbs

c. 1883
Oil on wood, 16 x 25 cm
The Ian Woodner Family Collection, New York

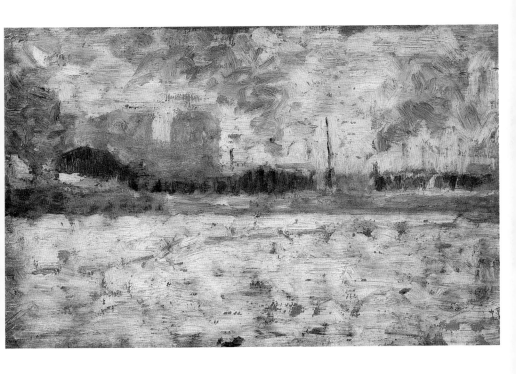

carefully arranged either facing away, opposite, or in profile, sat at right angles, lounging horizontally, drawn upright amidst bands of shadow, similar to the modernising work of Puvis [de Chavannes].

Is it not a prodigy who is capable of reaching greatness in joyfulness of colour shades without a

Tree Trunk

c. 1883
Conté pencil, 31.5 x 24 cm
Musée du Louvre, Paris

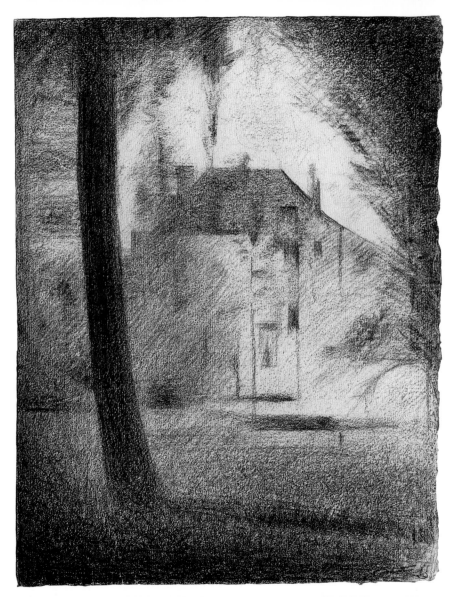

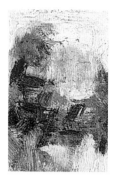

single fragment of the ancient materials which the academic painter Pierre Puvis de Chavannes used?

Seurat did not have need of introducing Greek figures or temples into his landscapes to give them gravity or style. It was his entire work which suggests to us a temple with a thousand pillars

Clothes and Hat

c. 1883
Oil on wood, 17 x 26.2 cm
Paul Mellon Collection, Upperville (Virginia)

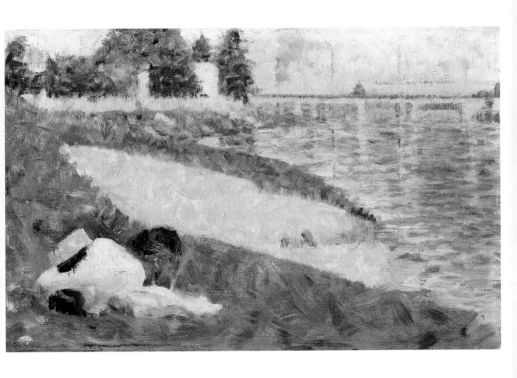

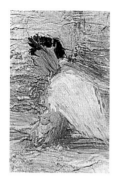

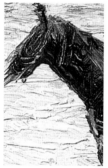

or columns, with his repeated vertical lines over clean horizontals. These are represented with the figures he painted, tree trunks, masts, lighthouses erected between level terrains and increasing shadows, and the pediments of greenery.

No one knew better than Seurat, in widening his canvas, how to arrange his measurements in

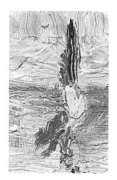

Horse and Boat

―――――――――

1883
Oil on wood, 15.5 x 25 cm
Paul Mellon Collection, Upperville (Virginia)

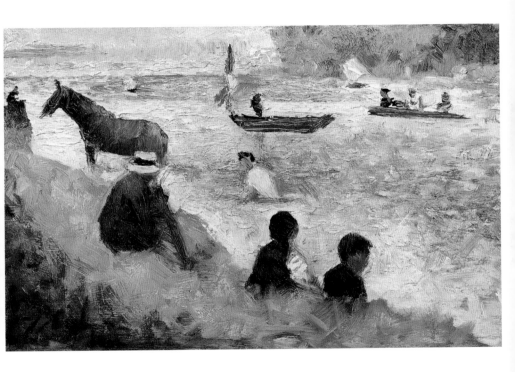

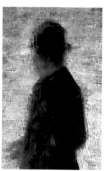

such a way as to communicate to the viewer the impression of strength created by the science of angles, according to which directions intercede with each other.

Much like Cézanne, we could consider that he practically explained that which was to become Constructivism in Russia by an expressive geometry

Angler (detail)

c. 1884
Oil on panel, 24 x 15.2 cm
Private collection, on long-term loan to
The Courtauld Gallery, London

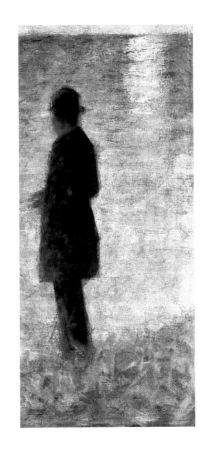

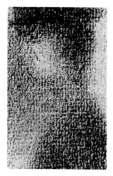

of the most acute modernism. Seurat was overlooked until later analysis and then belatedly recognised as master of immediate representation, fortuitous games of light, Synthetist, or, better, the implacable logician who only used this light to conserve and characterise the appearance of objects once and for all.

The Bustle
――――――
c. 1884
Conté crayon, Gillot ink on Michallet paper
highlighted gouache, 31 x 23 cm
Private collection

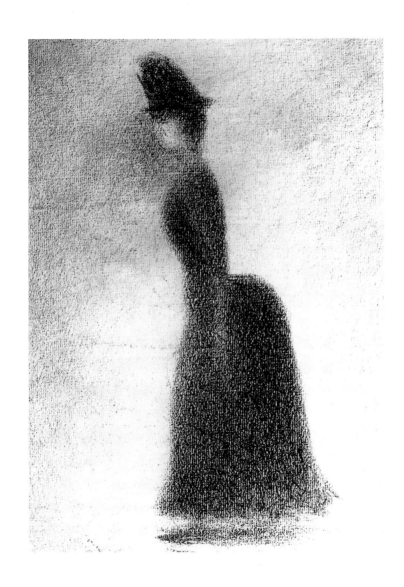

Circus, more than any other painting, affirms irreducible bias, which considers natural phenomena according to their expressive value, and not according to their literal existence, which has rejected them when need required it. This composition suggests enclosing ascending lights within a large curve, signifying the gaiety of the

The Couple
————————
1884
Oil on canvas
Private collection

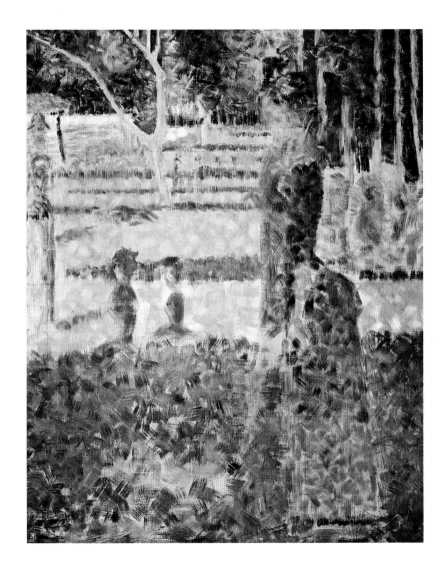

115

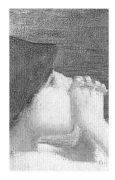

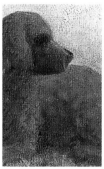

atmosphere at the circus. The unity of expression thereby was in preparation to increase the richness of a gilded atmosphere, fit for the joyful triumph of the white horse, mounted by a circus equestrienne. The bold arabesque and red of a clown's wig, emerging in the foreground, disturbs the white with an expression highly representative

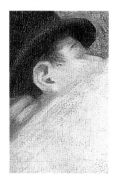

Bathers at Asnières

1884
Oil on canvas, 201 x 300 cm
The National Gallery, London

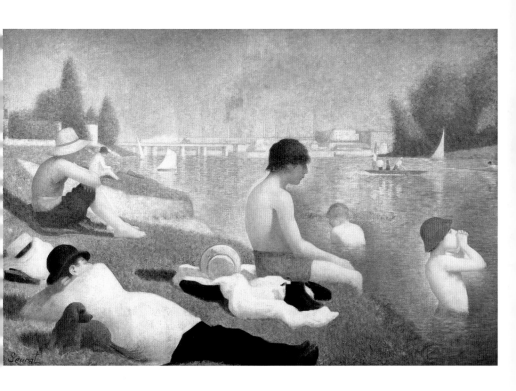

of a show. The attitudes and faces of the audience equally adhere to showing captured expression: sharp drawings to the point of animalism, the rewards of observation free from all contradiction. The painter even made the decision to use clothes to serve synthetic expression as they destroyed the ordinary with their exorbitant personal statements.

Bathers at Asnières (detail)

1884
Oil on canvas, 201 x 300 cm
The National Gallery, London

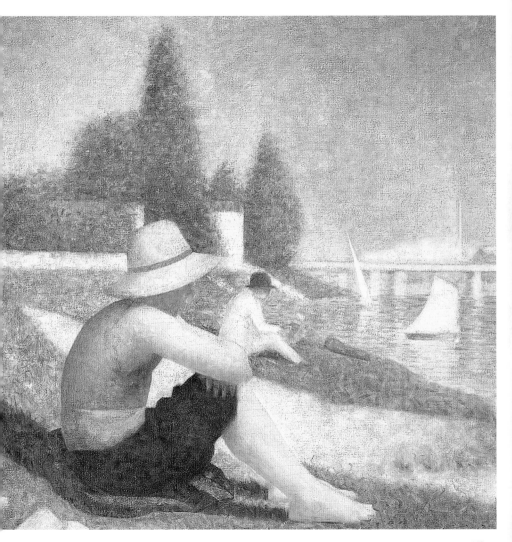

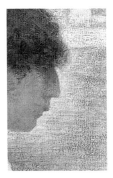

The little equestrienne, for example, is wearing a dress which is barely amplified, acting as a jovial offshoot of her being, similar to a song or a laugh. This small feminine form is that of a modern goddess of Fantasy and Grace; with her slender shapes, her head that of a mischievous fairy, and her rising movements which dissolve in the air.

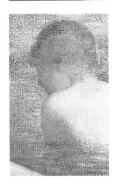

Bathers at Asnières (detail)

1884
Oil on canvas, 201 x 300 cm
The National Gallery, London

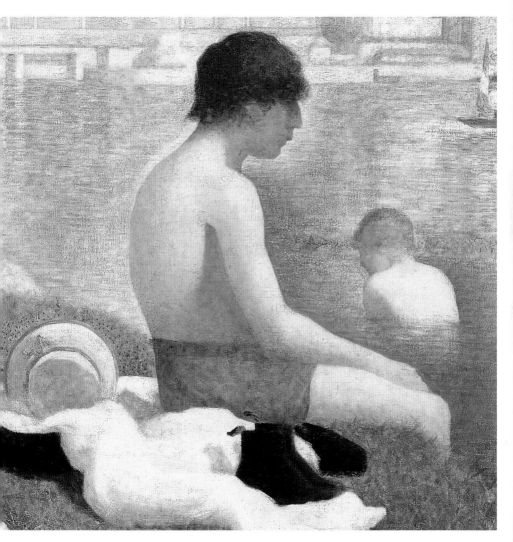

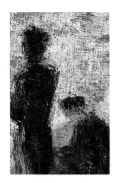

Such indications of feeling are only found amongst the works of Primitive painters such as Henri Rousseau. Unfortunately, *Circus* is not a completed painting. Here and there a trace of blue can be seen, which reveals the prior analysis commenting on the measures, sifting through the objects. But everywhere the canvas is covered,

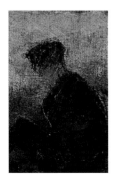

Study for A Sunday on La Grande Jatte

1884
Oil on wood, 15.6 x 24.1 cm
Robert Lehman Collection
The Metropolitan Museum of Art, New York

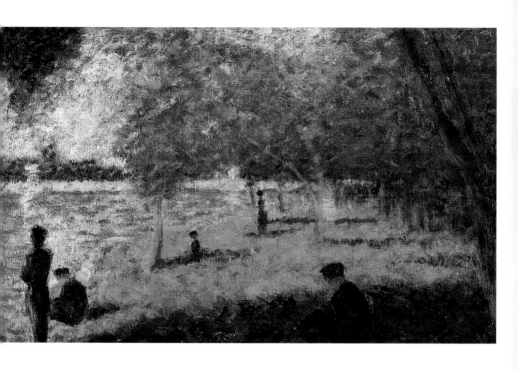

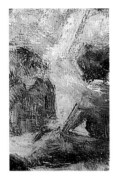

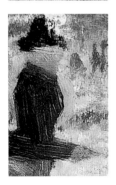

the painter has mercilessly pressed the shapes to make the fundamental idea spring forth, living beyond all the complications of poor likenesses. Seurat often went to the Fernando circus which was located close to his workshop. In fact, we now know that the equestrian number represented within this painting was actually the event's showstopper.

Oil sketch for La Grande Jatte

1884
Oil on panel, 15.5 x 24.3 cm
The Art Institute of Chicago, Chicago

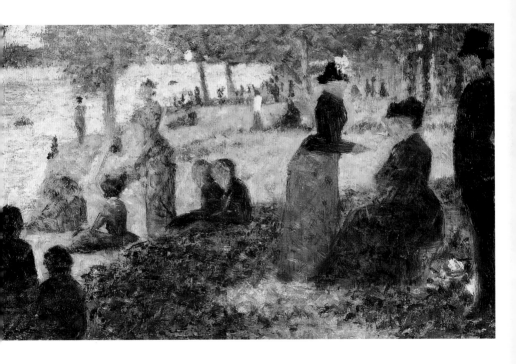

125

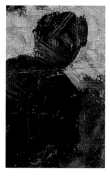

It was there that he studied the movements of each artist, acrobat, dancer, clown, and ringmaster. Having been painted at the end of his career, this is also one of his most clear and accomplished paintings in regards to his pictorial theory. The sobriety of his colours and the highly geometric shapes are the results of the painter's scientific concepts.

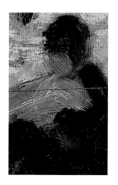

Study for A Sunday Afternoon on La Grande Jatte

1884
Oil on wood, 15.5 x 25 cm
Musée d'Orsay, Paris

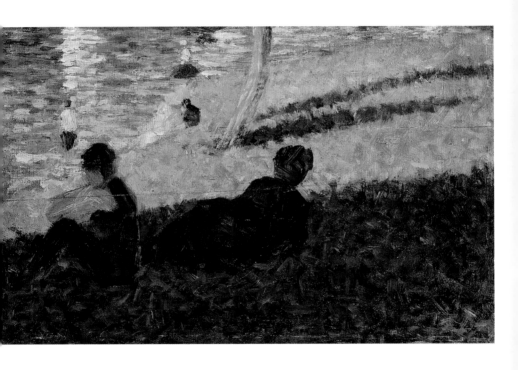

In our period of study, *Le Chahut* is also an isolated phenomenon. It featured the extravaganza of a quadrille from the Moulin-Rouge. Four dancers parade in convoy, emerging nearly opposite the viewer, in the foreground of the painting. Their actions are repeated in perspective.

Woman with a Parasol

―――――――――――――

1884
Oil on canvas
Private collection

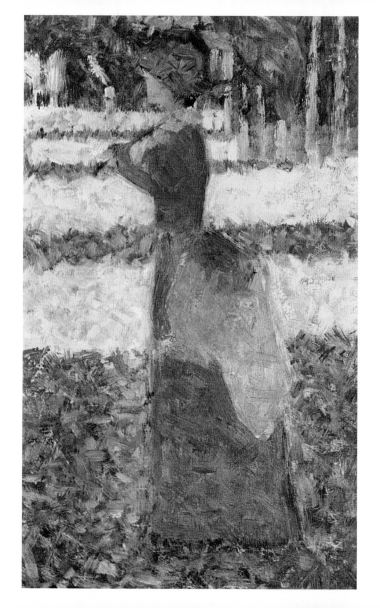

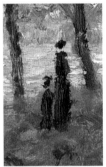

With the parallelism of their extended legs, straight, above the horizontal, with the assertion of the quadruple repetition of the arch of their slender torsos, and by the rhythm of gaiety propagated by their faces, they reach a cohesive energy akin to that of a Hindu symbol. The reason behind the predominance of tone over hue in *Le Chahut*,

Study for La Grande Jatte

1884-1885
Oil on wood, 16 x 25 cm
The National Gallery, London

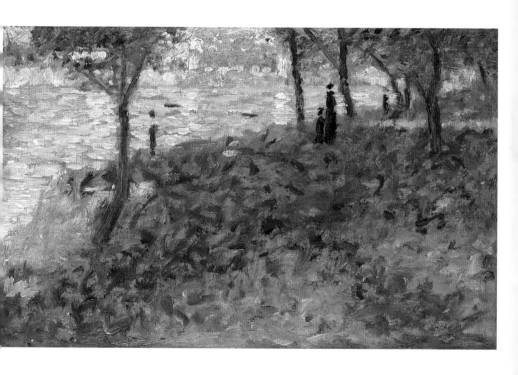

131

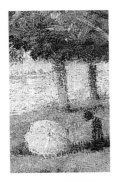

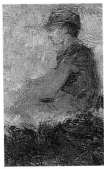

as in *Circus Sideshow*, is artificial light. In the severe arrangement of purple and blue, there is suddenly a white or burst of vermillion, bold notes from below, or from an extravagant hairdo.

As *Circus* and *Le Chahut* were inspired by moving forms, they could be reproached for not

Seated Figures, study for A Sunday Afternoon on the Island of the Grande Jatte

1884-1885
Oil on panel, 16.2 x 25.5 cm
Harvard Art Museums, Cambridge

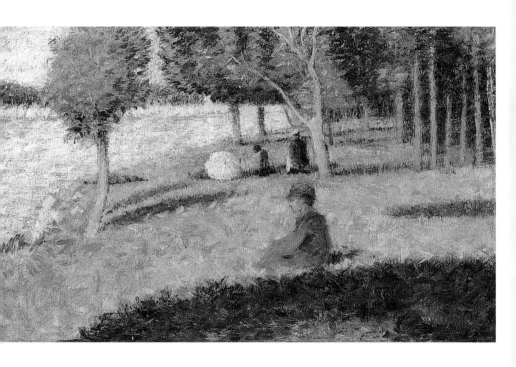

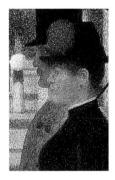

communicating the illusion of the movement of lines to the viewer. This is because Seurat had a synthetic concept of movement. He suggests extreme ideas for it through the demonstration of the point of equilibrium in an action's course, as in Egyptian or Khmer static art. He does not represent movement through the components of

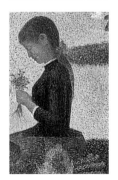

A Sunday on La Grande Jatte — 1884

1884-1886
Oil on canvas, 207.5 x 308.1 cm
Helen Birch Bartlett Memorial Collection
The Art Institute of Chicago, Chicago

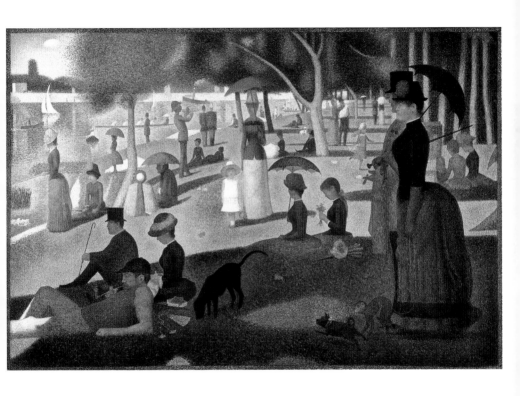

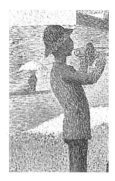

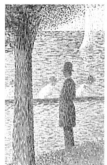

its phases, unlike Delacroix, Ker-Xavier Roussel, or Japanese art.

Differently representative of the art which Seurat focused on is the painting *Models (Poseuses)*. This large painting is not decorative in the usual sense. The three nude models, painted in the simplest of positions, were not linked together by an arabesque, but rather by a block of paint.

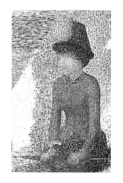

A Sunday on La Grande Jatte — 1884 (detail)

1884-1886
Oil on canvas, 207.5 x 308.1 cm
Helen Birch Bartlett Memorial Collection
The Art Institute of Chicago, Chicago

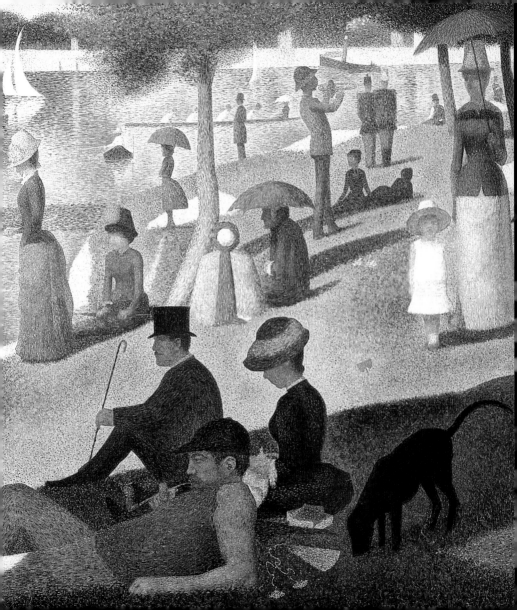

This presents a sort of triptych of feminine beauty. They naively impress their elegance upon the viewer with supreme disdain, to fool us with poor counterfeits of real material, showing themselves to be animated with the highlighting of their bodies. In the same way that Egyptian black diorite was able to evoke life better than the most faithful

Woman with a Monkey (study for A Sunday Afternoon on La Grande Jatte)

1884
Oil on wood panel, 24.8 x 15.9 cm
Smith College Museum of Art
Northampton (Massachussetts)

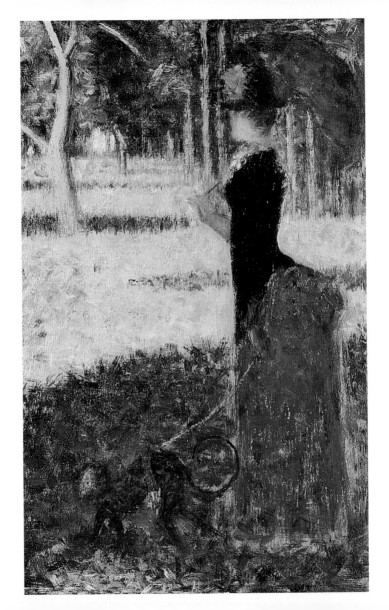

139

appearance of flesh, the abstract composition of these models, reduced to an expressive measure of light, cries out to our animalism and modern humanity. Indeed, it is possible to suggest that across all aspects of life which he represented, it was Seurat's own self which was displayed above all. But is this not the mark of the highest capability of

The Rue St Vincent, Paris, in Spring

c. 1884
Oil on panel, 24.7 x 15.5 cm
The Fitzwilliam Museum, Cambridge

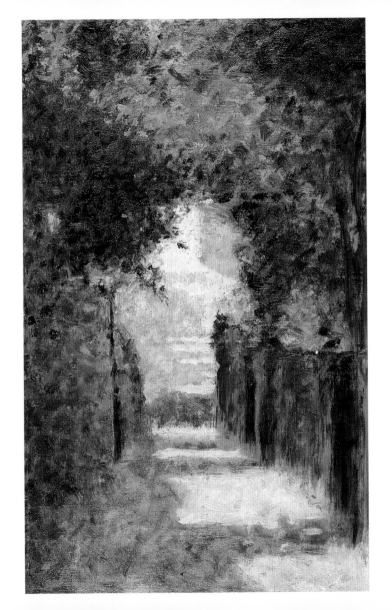

141

an artist, to recreate the entire world according to his own ardent desires? Godet wrote:

> Style is a product of life. It is not an object existing in itself which can be understood from without. It has an inner source. It exists within a strong character, to impose upon works that

A Paddle Boat

————————————

1884
Oil on wood, 17.2 x 26.4 cm
Private collection

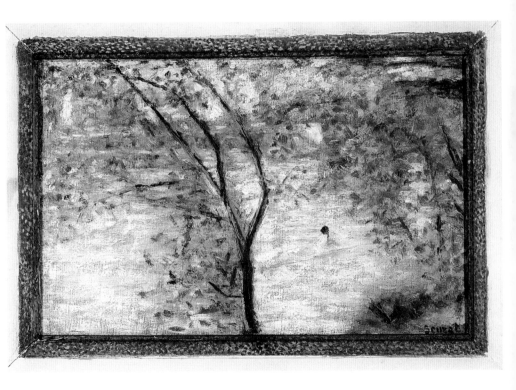

which it derives from the imprint of nature, its bias, and its sense of the Universe. This is done so that an order of general enduring value is generated within the community – almost always after a long period of blindness and unjust resistance – the expression of its needs and the language of its instincts.

Grandcamp, Evening

1885
Oil on canvas, 66.2 x 82.4 cm
The Museum of Modern Art, New York

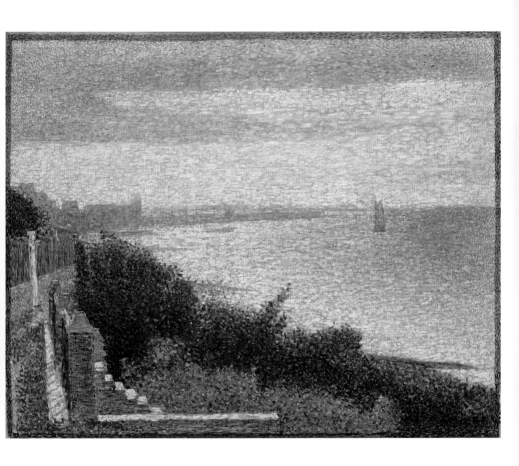

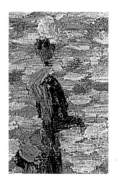

If this is a fair definition of style as presented in art's masterpieces, it implies the immediate necessity to recognise Georges Seurat, one of art's great innovators, as the creator of an exceptionally expressive style, who will always generate the deepest admiration in both France and abroad.

The Morning Walk

1885
Oil on wood, 24.9 x 15.7 cm
The National Gallery, London

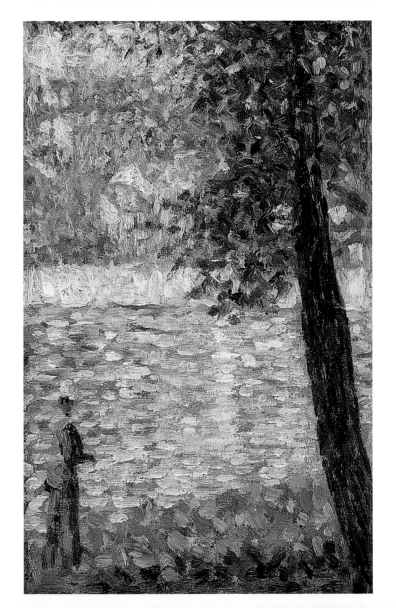

147

The Drawings

As clear in his paintings as in the splendour of his colour shades, Seurat's poetry was also to be found within his conté drawings. These are the only ones in the world which can be studied alone, allowing the possibility of catching the artist's secrets, akin to how one could study a wood sculptor,

The Race at Grandcamp

1885
Oil on canvas, 65 x 81.2 cm
Private collection

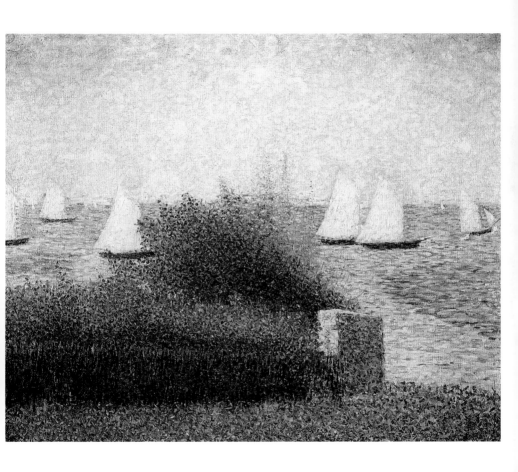

149

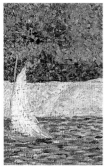

without the aid of wax, bronze, or precious marble. He always afforded great importance to the simple drawing. Moreover, it was a drawing which he presented during his first participation as an artist at the Salon des Salon des Indépendants.

Although similar to a sculptor who is well-versed in the sacrifices demanded by wood – the grain of which can be split by a curved outline of

The Seine at Courbevoie

1885
Oil on canvas, 81 x 65 cm
Private collection

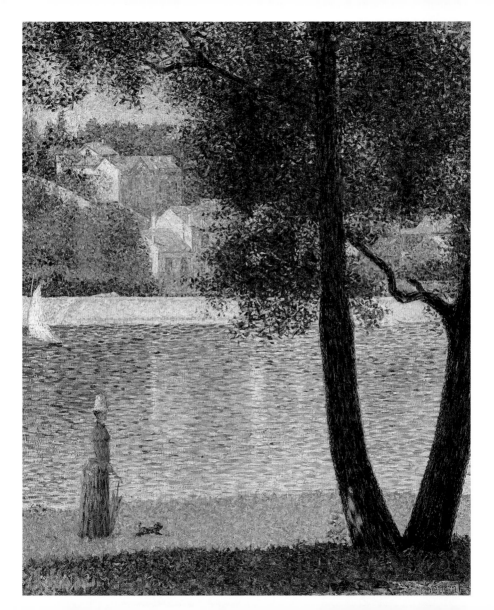

an eye or by a nail – Seurat knew which work conditions gave black and white the exceptional power which we now admire. He was careful, with tiny details, to break down expressive blocks. The large and intense rubbings of conté, without any hint of heaviness, on pages of resistant grain Michallet paper, served the artist's need to express

Condolences; Family Gathering

1885-1886
Conté crayon on Michallet paper, 24.1 x 31.8 cm
Private collection

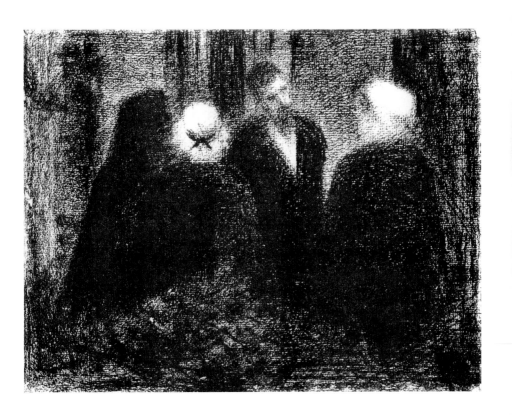

himself in long curves, in clean angles, and in simple shapes. The result is a deep velvety material; free from the trickle and gleam characteristic of Seurat's contés. These effects should not be confused with the properties of conté pencils in general: works by Odilon Redon and Charles Angrand show lustre and fluidity respectively,

Women at the Water's Edge

1885-1886
Oil on wood, 15.7 x 25 cm
R.J. Bernhard Collection, New York

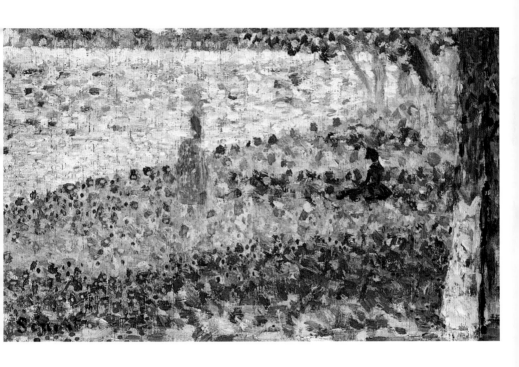

incompatible with the hieratic immobility that Seurat was looking for. The instinct that the painter bore was, in effect, to create from the start an aspect of the surface which would most sensitively reflect the character of the shapes which he designed. It is clear, for example, that the ductile substances created by Bonnard, shown through

Le Bec du Hoc, Grandcamp

1885
Oil on canvas, 64.8 x 81.6 cm
Tate Collection, London

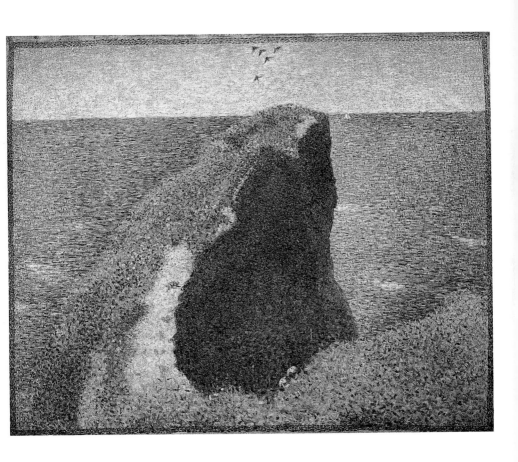

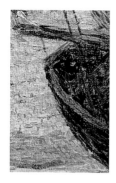

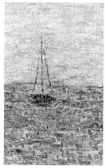

thick and round lines, loops, patches, and maculation, were used by Bonnard to create a world made of soft curves which stretch, collapse, bubble, and ripple like water. Such an image prohibits the inclusion of Seurat's poetry (using as he did the brittle nature of the conté drawings on Michallet paper), which are in contrast cleanly drawn, and

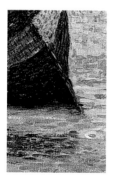

Boats, Lowtide, Grandcamp

1885
Oil on canvas, 16 x 25 cm
Private collection

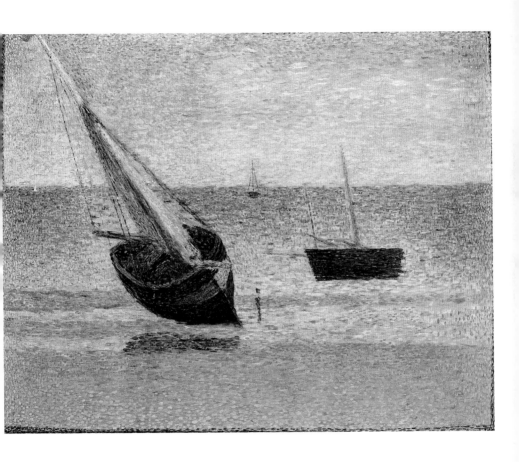

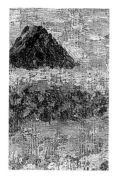

are reminiscent of a world of svelte architecture, rigidly built. It is therefore illogical to say that between two such masterful painters one possesses better materials than the other. It is impossible to compare them; the only way possible to favour one artist is to reject the other. More precisely, one can say that they are more or less equally matched.

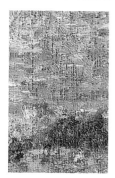

Fort Sampson in Grandcamp

1885
Oil on wood, 15.5 x 24 cm
Private collection

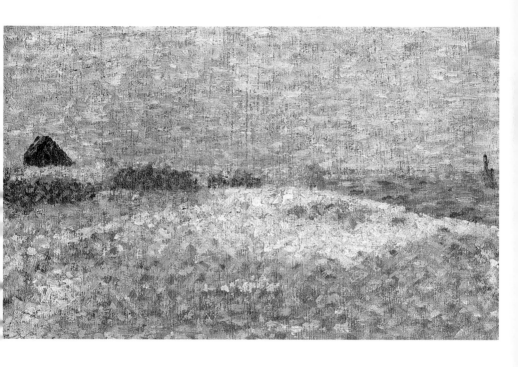

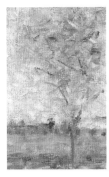

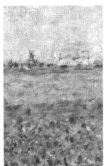

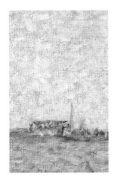

All of Seurat's drawings testify to the fortuity of this instinctive choice. Innocent of devious methods, devoid of illustrious commissions, they offered their new velveteen images with all the candour of works by Naïve painters which were spontaneously born to serve thoughts, images, and emotion. To assure the meaning of these pictorial expressions,

La Luzerne, Saint-Denis

1885
Oil on canvas, 65.3 x 81.3 cm
National Galleries of Scotland, Edinburgh

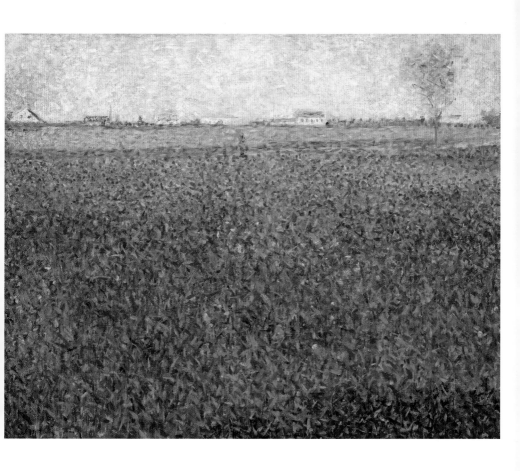

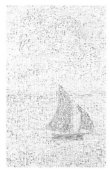

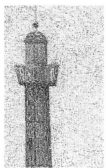

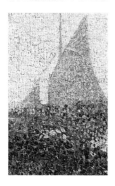

Seurat was content to minutely regulate the etchings of his pencils to either enlarge or reduce each position. These effects or deteriorations were those which he praised the power of in his work *Théorie des contrastes*.

It was of no consequence to Seurat if during his painting he destroyed a multitude of

Harbour Entrance at Honfleur
(Bout de la jetée à Honfleur)

1886
Oil on canvas, 46 x 55 cm
Kröller-Müller Museum, Otterlo

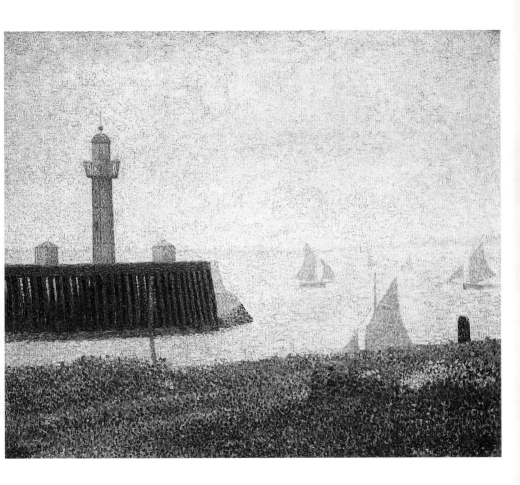

picturesque elements. He did not regret the absence of a single expressive form reminiscent of a Honoré Daumier, Jean-Louis Forain, or a Maximilien Luce: facial features, wrinkles, or musculature. What remained, therefore, of human characteristics in all of his characters, if not gentle allusions? What remains in *Nude*,

A Corner of the Harbour of Honfleur
(Coin d'un bassin à Honfleur)

1886
Oil on canvas, 81 x 65 cm
Kröller-Müller Museum, Otterlo

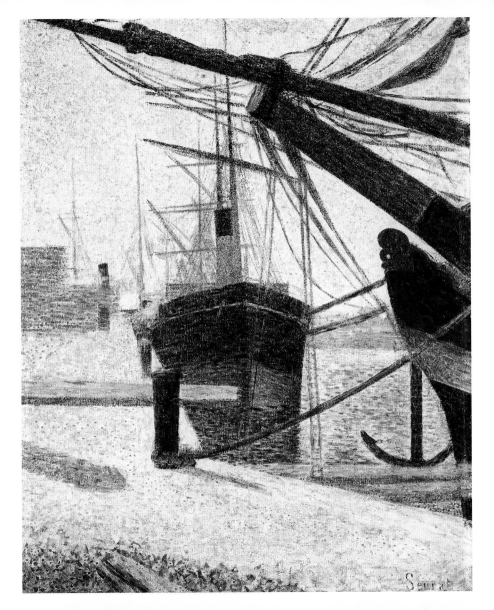

where white radiates, if not the double allusion to a dome of flesh and a fragment of a star, but uses nothing more than a back to make us see this. An arm has remained by accident in this drawing. Seurat detailed the deltoid muscle, triceps, and biceps, whilst the torso radiates. The painter felt the incoherence of this simultaneity, and in

Le Port de Honfleur

1886
Conté crayon on Michallet paper, 58.4 x 77.5 cm
Private collection

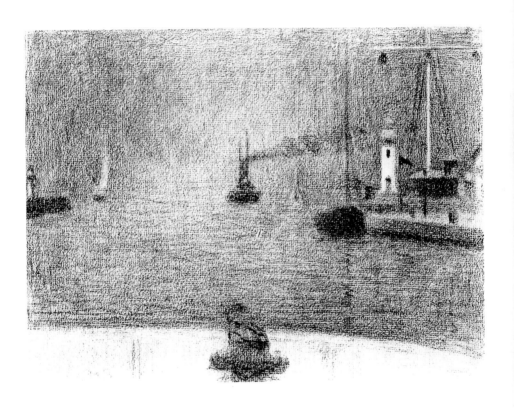

Bathers at Asnières, the painting in which the nude model can be found, the indiscreet muscles have been removed. Unlike certain pedants, Seurat did not have to prove that he could do what he had no wish to. In *Portrait of the Father* nothing remained of the head, hands, napkin,

Model Standing, Facing Front (Study for Models)

1886
Oil on wood, 25 x 15.7 cm
Musée d'Orsay, Paris

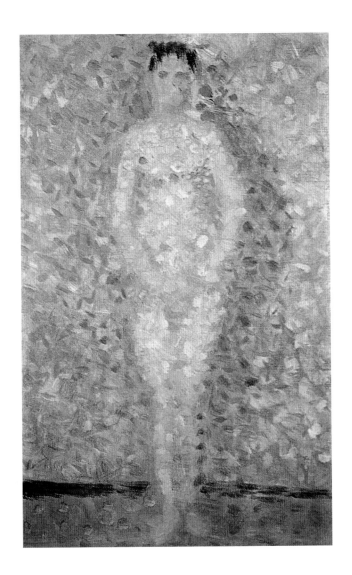

tablecloth, spoon, or the diner's bottle of wine other than these essential allusions: a dark oval, inclined against a square white cover; a black ball, agile against the white; a stick which, ideally, is threaded and ready to plunge into a nearly intangible croissant; an elongated cone, black,

Le Bas Butin Beach in Honfleur

1886
Oil on canvas, 67 x 78 cm
Musée des Beaux-Arts, Tournai

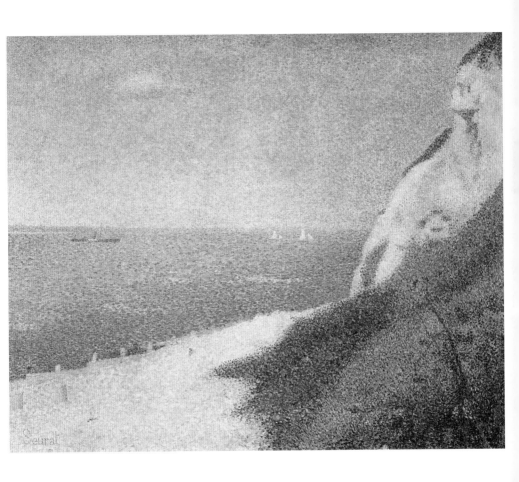

made miniscule against the torrent of white. Respect for his father did not recall Seurat to the fact that his own face bore the same features; his hand and fingers; his distorted soul was indifferent to the expression of watchful eyes, keen nostrils, ready lips, and skilful fingers.

Evening, Honfleur

1886
Oil on canvas, with painted wood frame, 78.3 x 94 cm
The Museum of Modern Art, New York

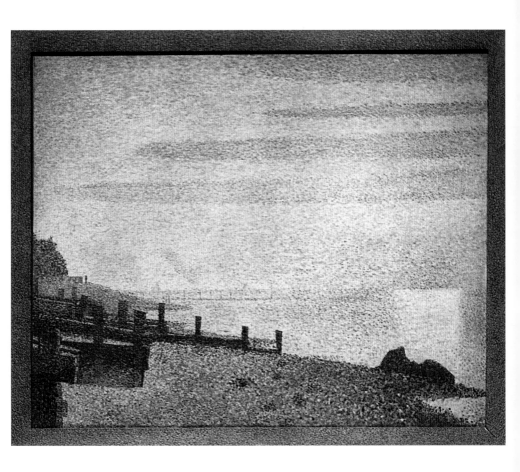

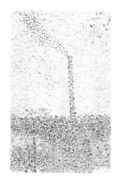

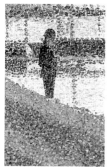

Is it necessary to explain how he accomplished this; these elliptical shapes of a portrait whilst saying that his theory obliged Georges Seurat to sacrifice the softer aspects of life? This supposition would be likely if there was a single way of applying this theory. But there can be as many ways to depict a reaction as there are painters

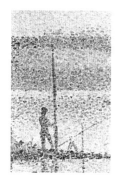

Bridge at Courbevoie

1886-1887
Oil on canvas, 46.4 x 55.3 cm
The Courtauld Gallery, London

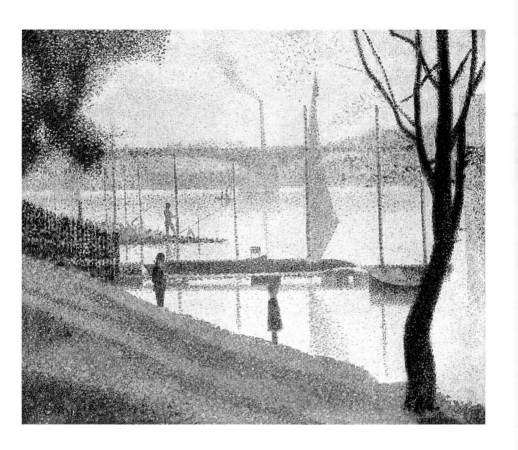

anxious to relate, on a similar surface, shapes in three dimensions: the methods of Leonardo da Vinci, Rembrandt, or Delacroix; or the way of Cézanne, Vuillard, or Picasso. Effectively, black which, on the borders of white, does not acknowledge more intensity, does not react in conforming to the physical laws of contrast, and

Eden Concert

c. 1886-1887
Conté crayon, blue chalk
and brown ink on paper, 29.5 x 22.5 cm
Van Gogh Museum, Amsterdam

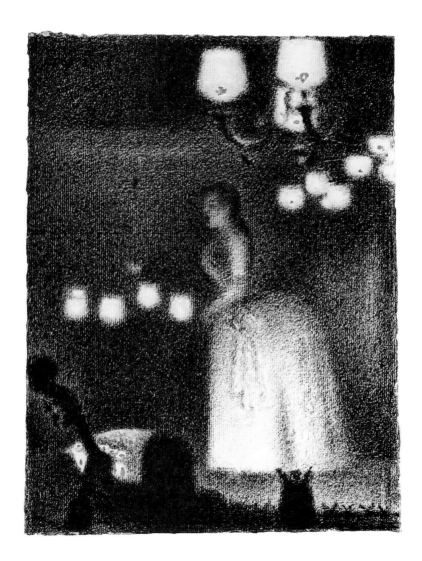

seems to ignore this white which it should be exalting, so consequently denies the shape which the white is representing.

If it is not contrasts which assault shapes, perhaps we could say that it is rather deformations of an "effect", for example, which frustrates the contrasts? As a result, should the mass of white or

At the European Concert
———————————————
c. 1886-1887
Conté crayon, blue chalk
and brown ink on paper, 29.5 x 22.5 cm
Van Gogh Museum, Amsterdam

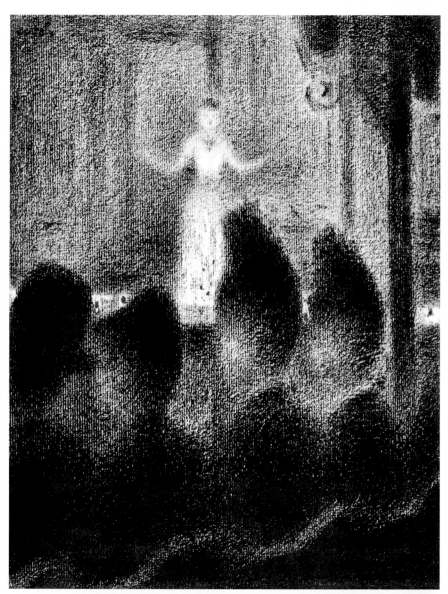

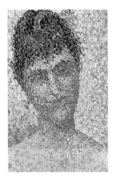

black shapes represent the striking simplicity of the luminous effect of light? No, because Seurat did not paint the effects of light, because an accidental illumination does not necessarily retain our understanding, but rather our curiosity. If the painter of new appearances of shapes finds them of worth, they only affect him through their

Models (Poseuses)

1886-1888
Oil on canvas, 200 x 249.9 cm
The Barnes Foundation, Philadelphia

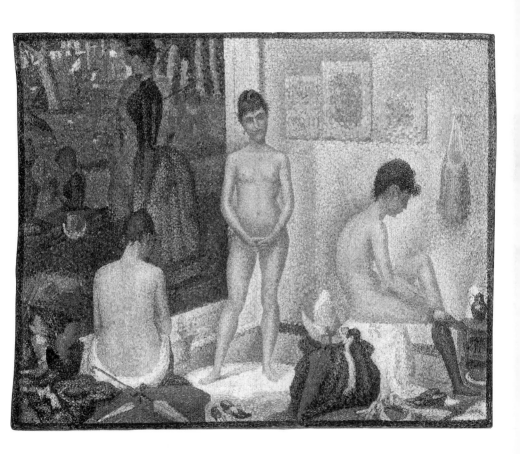

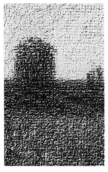

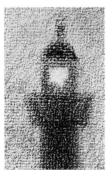

pleasant appearances. Photographs relentlessly surprise us with curious fantasies. Indeed, it must be said that Seurat's contés are luminous because they enflame the white paper with contrasts. They are drawn with light, but they do not copy light itself, as there is nothing positive or negative in it which is meant for our eyes.

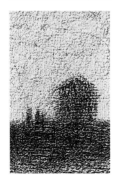

The Lighthouse at Honfleur

1886
Conté crayon heightened with
gouache on Michallet paper, 24.1 x 30.8 cm
Robert Lehman Collection
The Metropolitan Museum of Art, New York

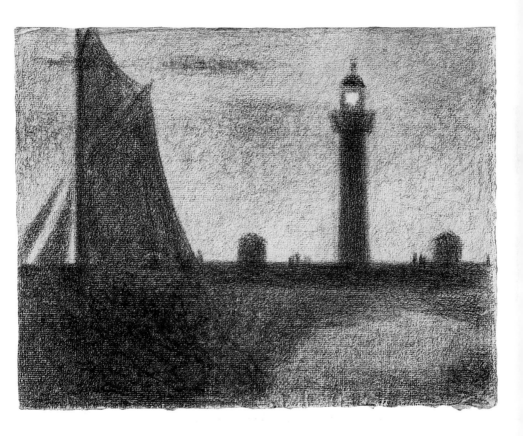

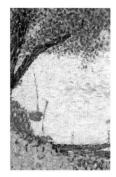

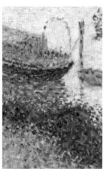

If it was the wish to "render" the sun which caused Seurat to remove the facial features of his models and the branches in the trees, for example; would it more precisely be the wish to give a synthetic equivalent or outline, of these faces and trees, under the pretext of the sun? It is convenient to admit that the broad rhythms of the clear and

Grey Weather, Grande Jatte

c. 1886-1888
Oil on canvas, 70.5 x 86.4 cm
The Walter H. and Leonore Annenberg Collection
The Metropolitan Museum of Art, New York

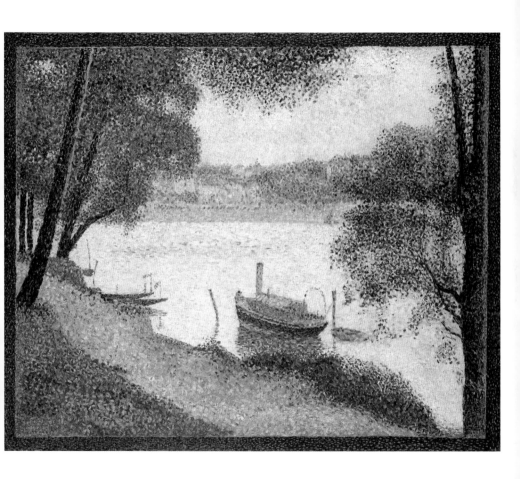

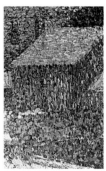

obscure (excluding many details) radiate a concept of amounts, dubbed 'synthetic'. However, does this word aptly characterise the rapport that Seurat's art had, he who would omit expression, with the work of Carrière, who put it above all else? With that of Bonnard who could not depict a character without precisely detailing the button

Hospice and Lighthouse of Honfleur

1886
Oil on canvas, 66.7 x 81.9 cm
National Gallery of Art, Washington, D.C

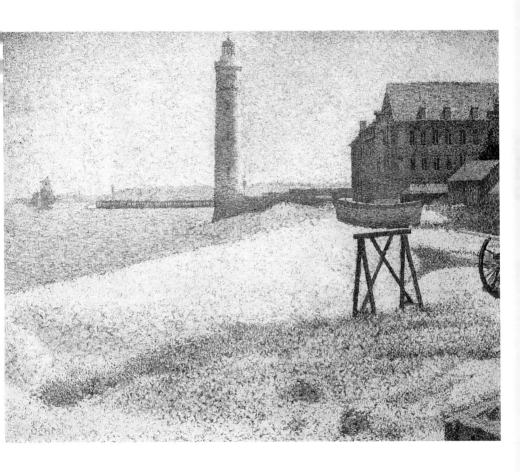

189

adorning it's patterned coat? With the work of a Naïve painter such as Henri Rousseau, who depicted a tree by a single palm leaf, comprised of an array of leaves? Should these latter be called scholars? More likely, amongst the artists there were not groundbreakers and Synthetists as there were among the intellectuals. Rather, mediocre painters,

"Maria" in Honfleur

1886
Oil on canvas, 54.5 x 64.5 cm
Nardoni Galerie, Prague

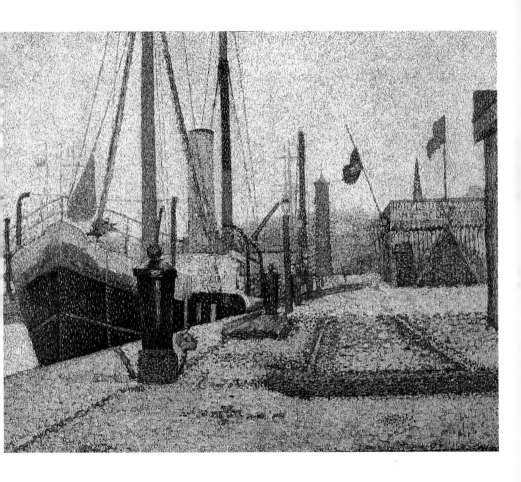

irresolute, incapable of choice, lacking in love, and who overlay all aspects in contradictory rhythms; but also those of excellence, such as those who have already been named, who, through adapted patterns, knew how to impose their ardent preferences on us. These preferences varied according to the thoughts of their creator.

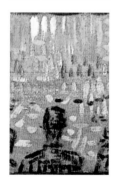

Study for Invitation to the Sideshow

1887
Oil on panel, 16.5 x 26 cm
Foundation E.G. Bührle Collection, Zurich

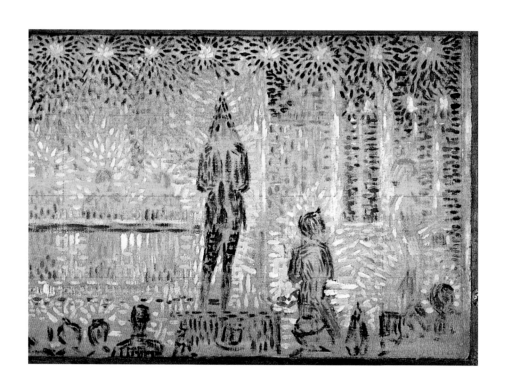

A Naïve painter, like a child, was preoccupied with the eyes, mouth, and nose, which act primarily to attract or repel the viewer from a figure. Of a tree, he would prefer above all to depict what he knew about it through the sense of touch: the flowers and the fruit amongst the leaves,

Model from the Back

1887
Oil on wood, 24.3 x 15.3 cm
Musée d'Orsay, Paris

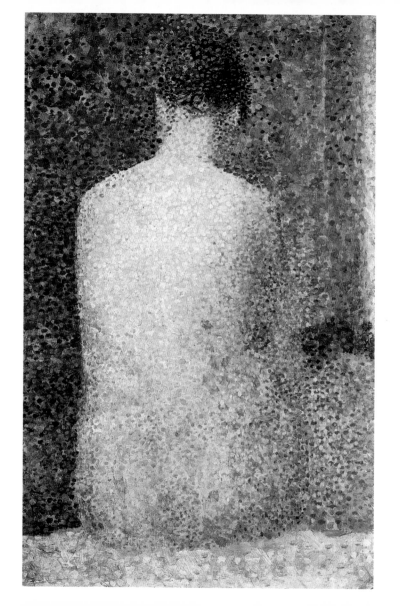

rather than its curve. The pleasure derived from the work of a Modernist such as Seurat did not have need to use touch as an intermediary with the world: new senses, created by an acute intelligence, gave him the ability to mentally discover the roundness of a tree, an enjoyment

Café-concert

1887-1888
Conté crayon heightened with white chalk, 31.4 x 26.6 cm
Cleveland Museum of Art, Cleveland

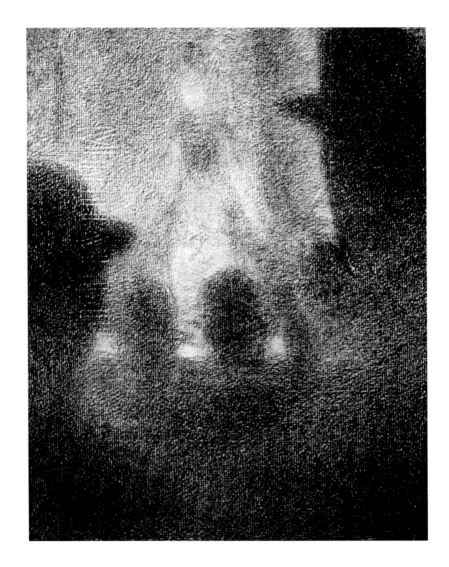

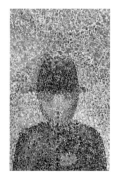

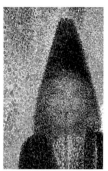

unknown to the Primitives: the love of a Seurat leaves other impressions than the love of a Benozzo Gozzoli.

In addition to the fact that the word "synthesis" does not imply love, it strays again into the nature of creation by letting us suppose that in terms of the shapes which are omitted for more simplicity,

Circus Sideshow

1887-1888
Oil on canvas, 99.7 x 149.9 cm
The Metropolitan Museum of Art, New York

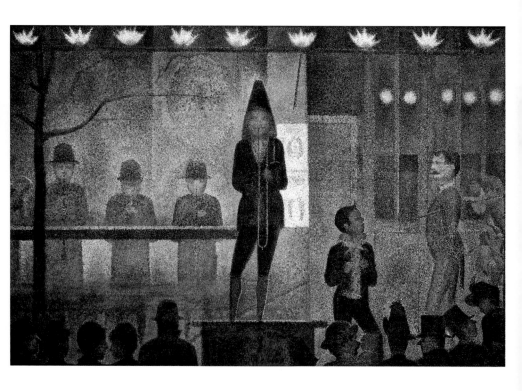

199

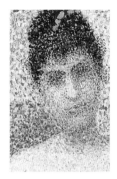

the painter renounces their place in the space which encloses them all. And yet, Seurat does not only omit them, but he denies them. He does not start again, he invents, and the shape which he invents excludes that which he has already denied. The elliptical form of a hand of a diner,

Model Facing Front

1887
Oil on wood, 25 x 15.8 cm
Musée d'Orsay, Paris

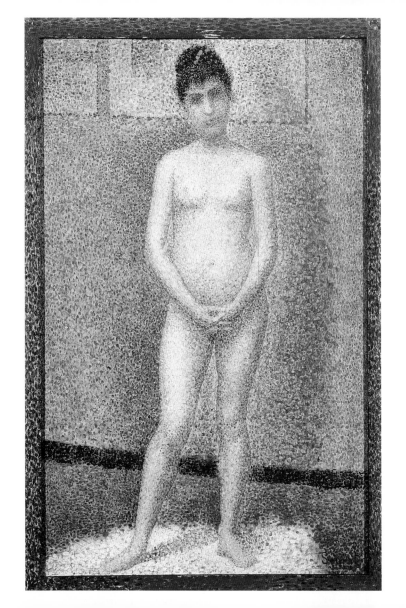

for example, does not suffer the reintegration of its fingers. Also, removed from the fact that the same objects represented in the works of different painters should be presented with common qualities, these properties have the tendency to be successively denied. From the same shape which

Model in Profile

1887
Oil on wood, 24.7 x 15.5 cm
Musée d'Orsay, Paris

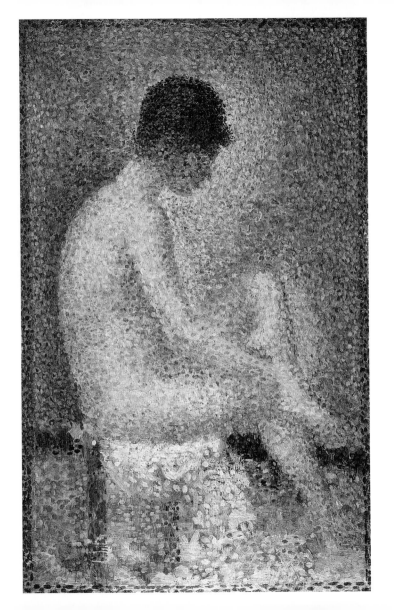

203

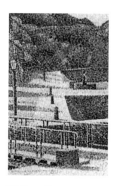

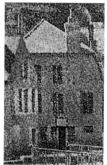

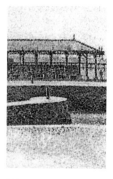

Cézanne said was built as a crystalline edge, Bonnard claimed that it undulated like water.

To sum up, it was not with the intention to conform to a theory that Seurat sacrificed revered elements, nor was it to reproduce the phenomenal, nor to experiment with synthesis,

Port-en-Bessin

1888
Oil on canvas, 66 x 83.2 cm
The Minneapolis Institute of Arts, Minneapolis

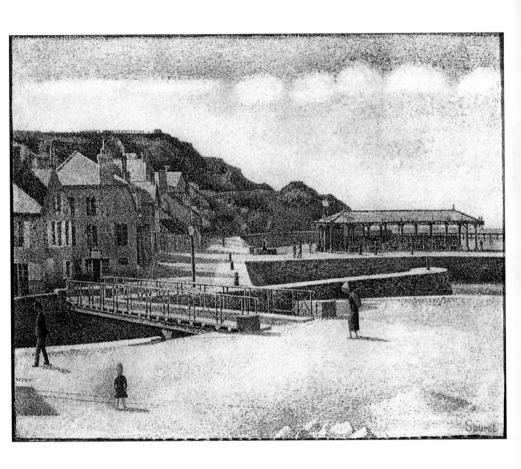

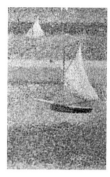

but it was to define the other reasons to love. However, the public, being very proper, did not welcome new wonders without knowing their names, and without first reacting negatively. Seurat was claimed to be stiff and his work of a schematic appearance, which threw him from the

Port-en-Bessin, Entrance to the Harbour

1888
Oil on canvas, 54.9 x 65.1 cm
Lillie P. Bliss Collection
The Museum of Modern Art, New York

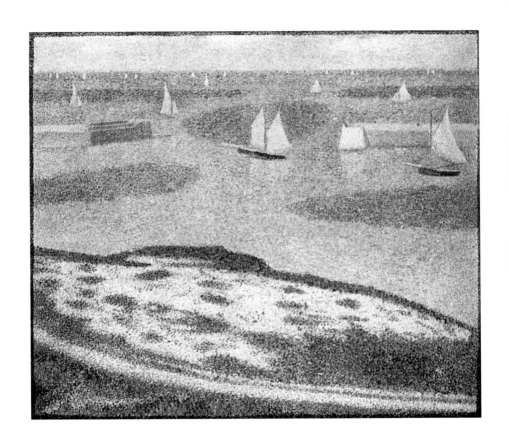

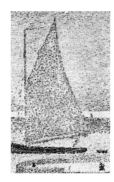

joys of emotions which he was accustomed to receiving. The passion that Georges Seurat expedited proved his strength as a painter is not worthy unless he has been first reproached by his public. However, with good reason, due to this, the inconsistency of technique reproached of

Port-en-Bessin, Outer Harbour at High Tide

1888
Oil on canvas, 66 x 82 cm
Musée d'Orsay, Paris

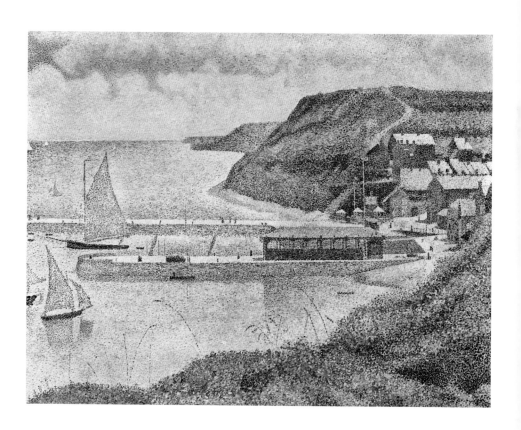

Signac became the nature of fluidity. The deformity reproached of Matisse became the nature of expressive proportions. A pure masterpiece was born wholly informed, as it did not adhere to any known conventions, but it was necessary to classify it thusly as it compelled the

Port-en-Bessin: The Outer Harbour (Low Tide)

1888
Oil on canvas, 54.3 x 66.7 cm
Saint Louis Art Museum, St Louis

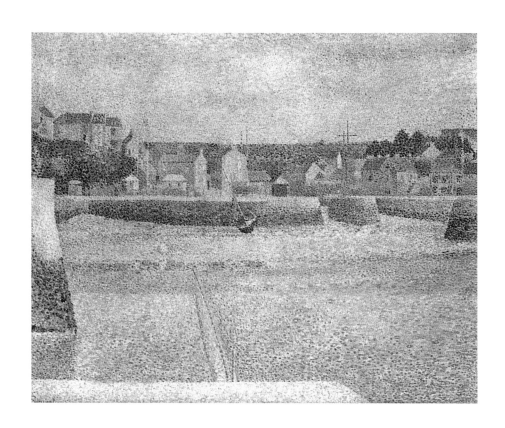

viewer to recognise a new form of soulful modelling as soon as these new aesthetic evidences were proven.

It was, therefore, figuratively, that the painters spoke of their modelling, as they did not literally undertake this, but rather the formation of their shapes. In the same way that a poet describes

Sunday at Port-en-Bessin
(Port-en-Bessin, un dimanche)

1888
Oil on canvas, 65 x 81 cm
Kröller-Müller Museum, Otterlo

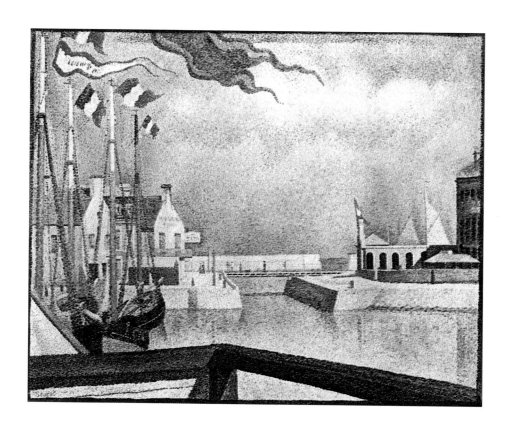

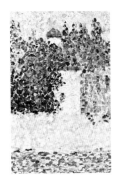

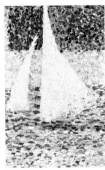

to us a girl's figure as that of a lily, to rescue us from the banal idea that we have of a shape and to make us imagine another via this description, the painters use expressive symbols to remove us from reality to startle us with an unforeseen angle of their personal choice.

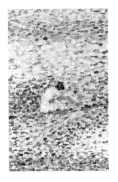

The Seine at La Grande Jatte

1888
Oil on canvas, 65 x 82 cm
Musées royaux des Beaux-Arts de Belgique, Brussels

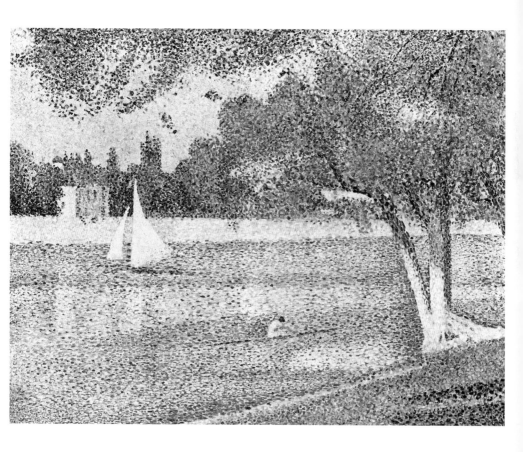

Seurat acted, in this manner, like the poets. Those who called him a Realist were those for whom a painter's imagination consists of the power to reassemble exotic, rare, ancient, or unusual objects in a frame. If, on the contrary, a painter's imagination is the power to react with an image to

Seascape at Port-en-Bessin, Normandy

1888
Oil on canvas, 65.1 x 80.9 cm
National Gallery of Art, Washington, D.C

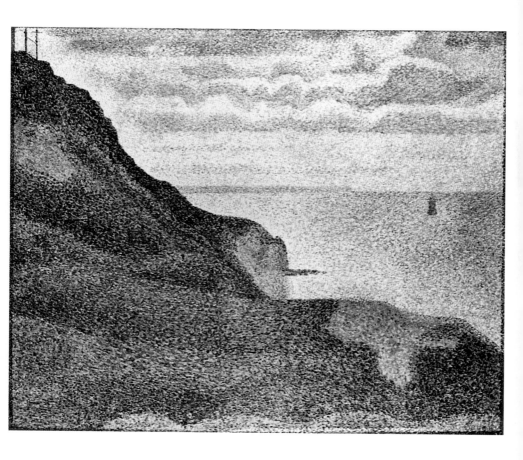

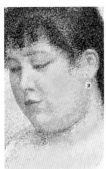

the shock received when faced with the seen world, it must be true that Seurat was endowed with a lofty imagination. This allowed him to be able to sit in front of any bank, tree, or wall, which many others may have already captured before him, and their defining features would alter in an instant,

Young Woman Powdering Herself

1888-1890
Oil on canvas, 95.5 x 79.5 cm
The Courtauld Gallery, London

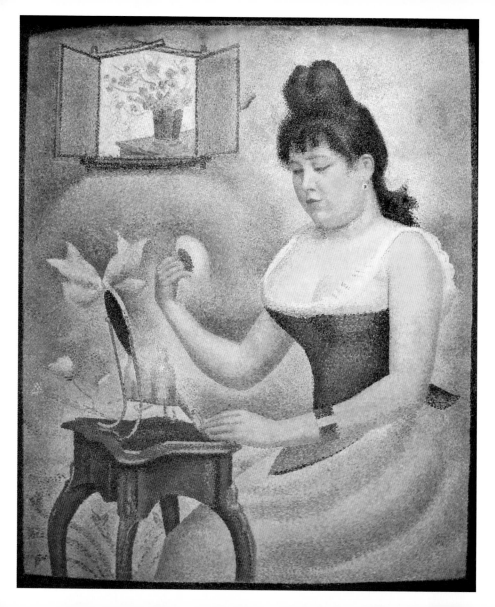

bending to his unique vision. When he was struck with a cylindrical characteristic, and rigidly created from it a composed image of a woman walking, he forgot everything about this form which didn't relate to this appearance. He was ground down by his own self, to the point where

Eiffel Tower

c. 1889
Oil on panel, 24.1 x 15.2 cm
Legion of Honor, Fine Arts Museums of San Francisco
San Francisco

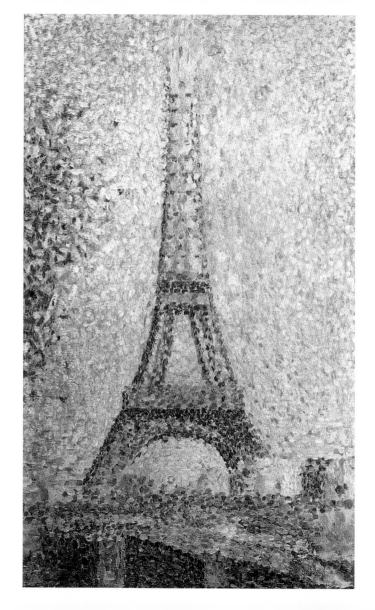

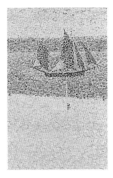

he had invented a manner of presenting architecture of meeting columns, regardless of pretty secular curves. We are talking here, of course, about his new feelings towards women. They were, effectively, an architectural order in their own right in Seurat's inventions; their symmetry, their nudity, and their steadfastness.

Le Crotoy, Downstream

1889
Oil on canvas, 70.2 x 86.3 cm
Private collection

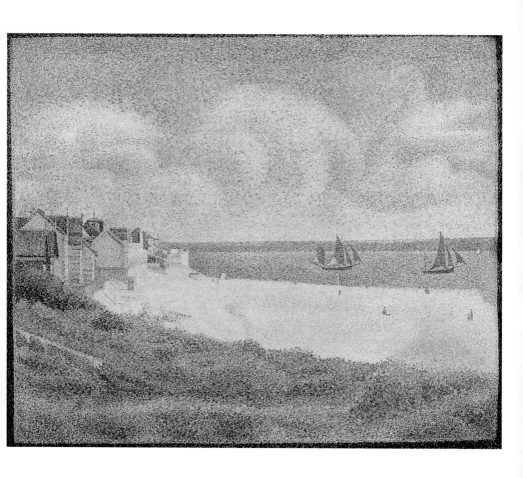

223

They especially exalt the voluptuous slowness with which they evade eye contact, an ample curve of a tree or a skirt, the pride and the brusque decision with which parapets or factory roofs, zealously straight, slice through the ground and slash the sky, themselves unbending to the very

Le Chahut

1889-1890
Oil on canvas, 16.9 x 14.1 cm
Kröller-Müller Museum, Otterlo

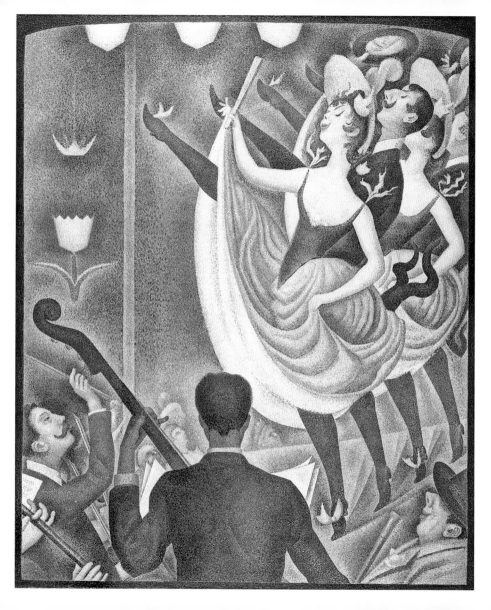

tip of their imperious ends. They celebrate the male costume with their harsh restrictions. They had glorified the shattered ramps of metro stairs which plunged, shining like lightning, to the round chasms of the station. We called these characters of our quays, our suburbs, in our new cities, ugly,

Study for Le Chahut

1889
Oil on wood, 21.5 x 16.5 cm
The Courtauld Gallery, London

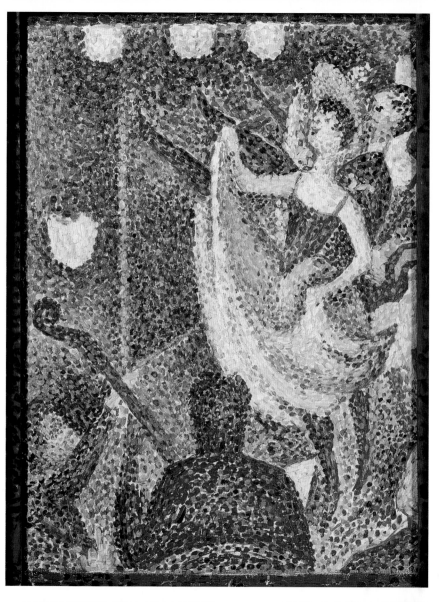

and we judged their characters to be unpleasant in potential. Seurat knew how to reveal their deep and subdued soul. Many other painters approached this task also, but they feared to let their wild sides be seen. They always decently veiled the hardness of the walls with either

Crotoy, Upstream

1889
Oil on canvas, 70.5 x 86.3 cm
The Detroit Institute of Arts, Detroit

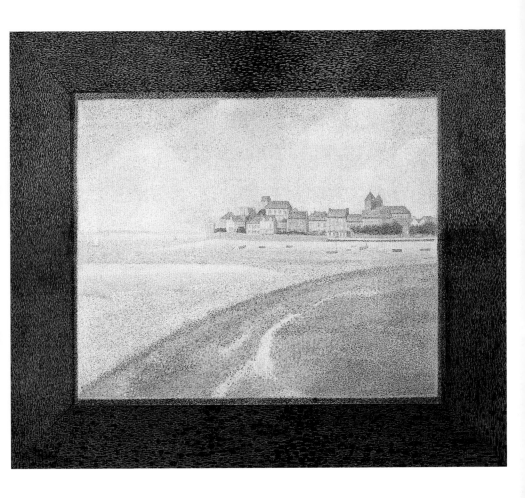

posters or ivy, the thinness of the iron bridge with smoke, and the nudity of the earth with flowers or rays of sunshine. Seurat, on the contrary, feared nothing, dusted off the ground, corrected the walls, shaved away the grass, and sharpened the corners of the roofs.

Petit-Fort-Philippe

1890
Conté crayon on Michallet paper, 22 x 28 cm
Private collection

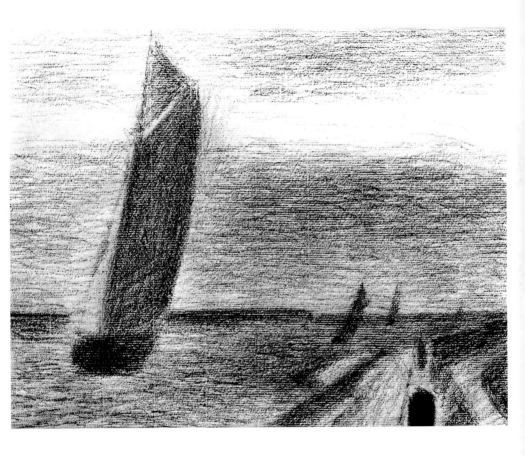

However, it does not suffice that a painter witnesses an original, innovative concept, or that he offers us the evidence of his invention, by curves and straight new lines. More than these signs are necessary, for few of us want to decode and understand them, refocusing our eyes first on

Boats and Anchors

1890
Conté crayon on Michallet paper, 22 x 29.5 cm
Private collection

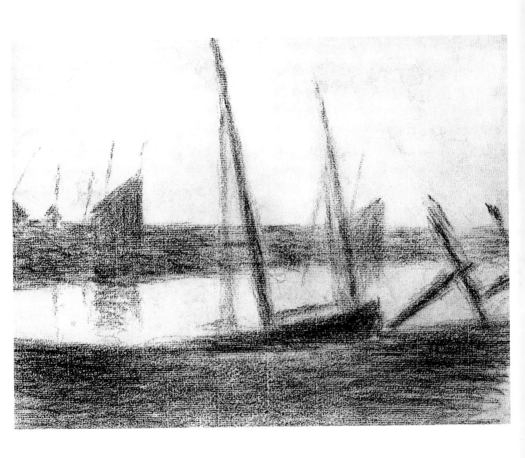

the sensual action of white and black, or on the combined colours which make them visible. The relationships of these directly sensitive elements are those which professionals in the art world call "rapports". They are analogies of similarities (the affinity of such white for such white, or of such

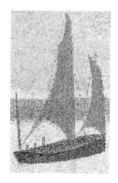

The Channel at Gravelines, Evening

1890
Oil on canvas, 65.4 x 81.9 cm
The Museum of Modern Art, New York

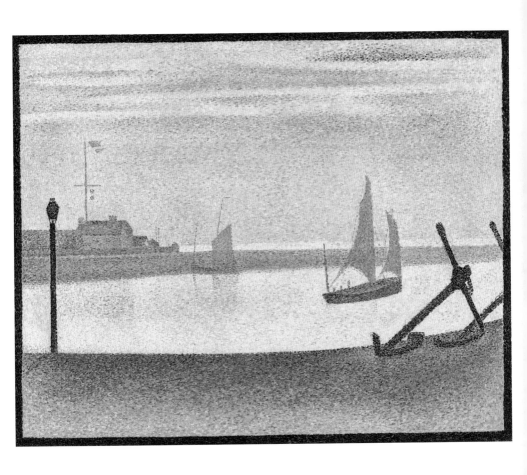

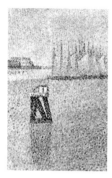

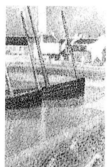

pink for such pink, and of such black for such black), or of analogies of contrasts (the affinity of such white for such black). These analogies or affinities have degrees of persuasive assimilation for our retinas, and to understand these degrees is to be a painter. Numerous people can affirm

The Canal of Gravelines, in the Direction of the Sea
(Le chenal de Gravelines: direction de la mer)

1890
Oil on canvas, 73 x 93 cm
Kröller-Müller Museum, Otterlo

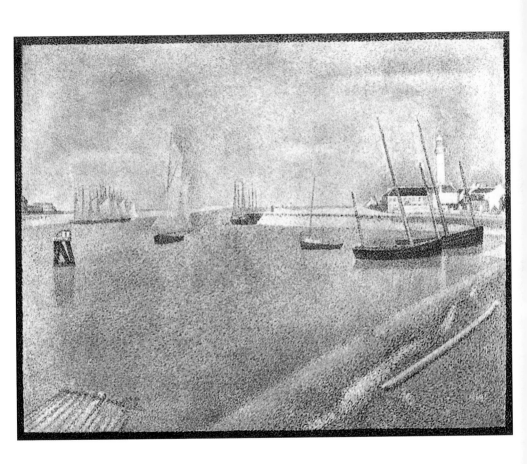

that they are painters, that is to say, technicians capable of concerning the senses in opportune tasks, but they are not necessarily inventors of humanity. It is therefore in vain that an artist may only be hired according to his mastery over these relationships: they cannot be his goal but,

The Channel of Gravelines, Petit-Fort-Philippe

1890
Oil on canvas, 73.3 x 92.7 cm
Indianapolis Museum of Art, Indianapolis

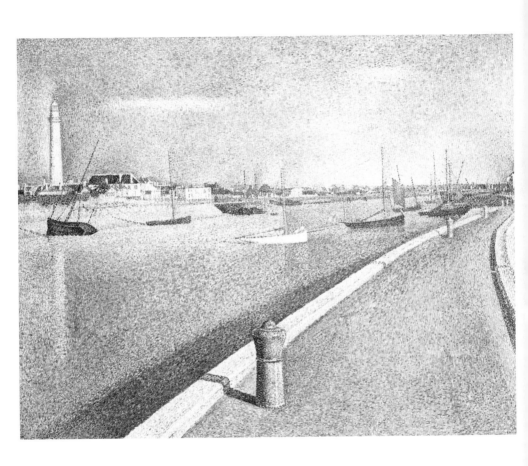

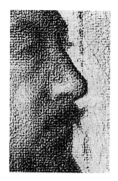

on the contrary, represent the necessary path of his thoughts towards us, the viewer; a path which invites us to climb towards him. Seurat's "rapports" were straight courses, ranging from the emotion of the eye to that of the heart. See, for his example, his drawing *Les Saltembanques*.

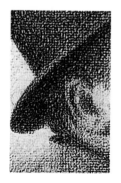

Portrait of Paul Signac

1890
Ink on paper, 34.5 x 28 cm
Private collection

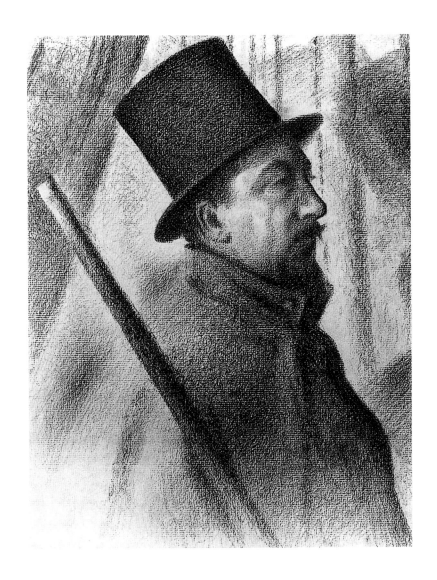

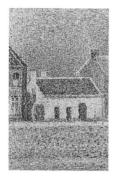

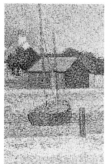

Our eyes are sought by easy degrees of white towards an even fainter white, encouraged to feel the rhythm and variety of curves of the tapered figures, thrown towards each other. Called by the contrasts of brilliant whites and intense blacks, we are encouraged to feel the balance of these

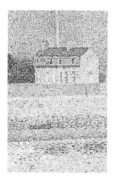

Gravelines Channel, Grand-Fort-Philippe

1890
Oil on canvas, 65 x 81 cm
The National Gallery, London

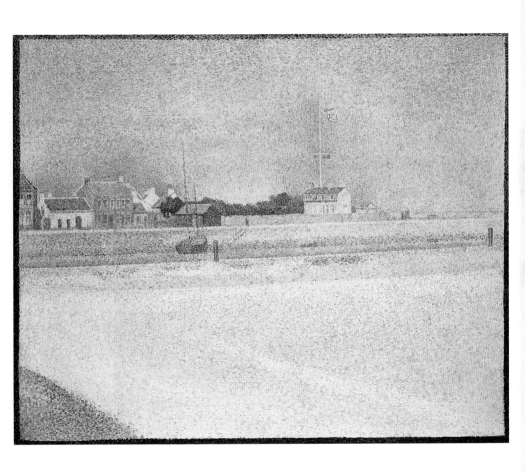

fraternal geometries: Pierrot's capped cone, and Columbine's hourglass tunic.

Georges Seurat passed the last summer of his life in Gravelines, a small town situated on the coast between Calais and Dunkirk. He came back with several drawings and "croquetons", a term which

The Circus (sketch)
———————————
1891
Oil on canvas, 55 x 46 cm
Musée d'Orsay, Paris

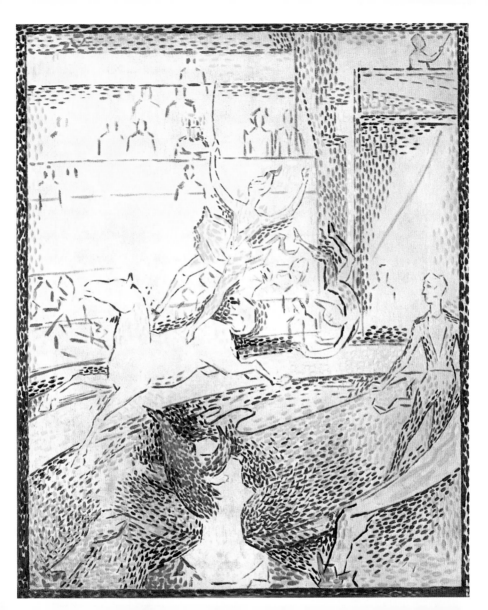

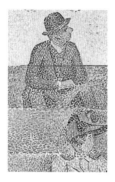

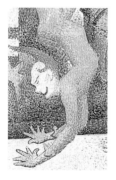

he himself used to describe the small painted panels of wood. Upon his return to the capital, he debuted his last great painting, *Circus*, which has earlier already been mentioned. He showed it before his death, incomplete but well-representative of his thoughts and artistic practices,

Circus

1891
Oil on canvas, 186 x 152 cm
Musée d'Orsay, Paris

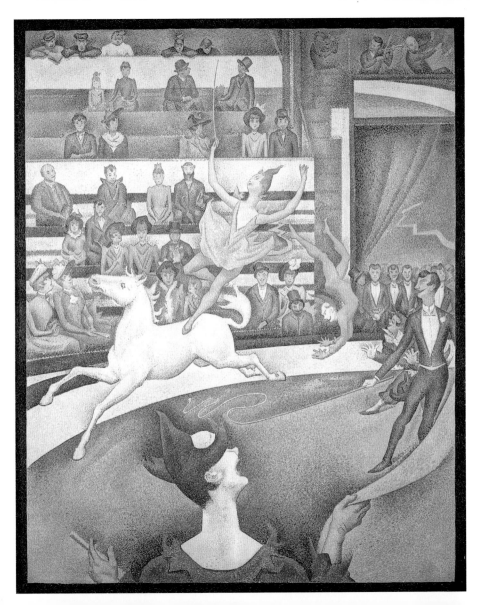

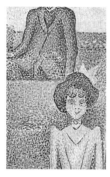

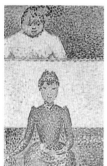

at the eighth Salon des Indépendants. In this way, in each of his works, from the comparison of colours to that of symbols and images, we are brought to understand, to embrace the harmony of the monument edified by Seurat; that of the praise of contemporary life.

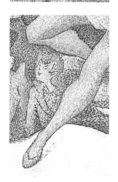

Circus (detail)

1891
Oil on canvas, 186 x 152 cm
Musée d'Orsay, Paris

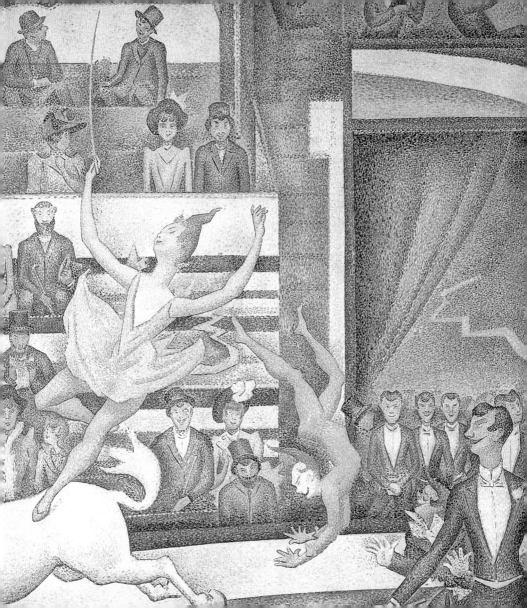

Index

A / B

C

T / W / Y